Our Smallest Towns
Big Falls, Blue Eye, Bonanza,
& beyond

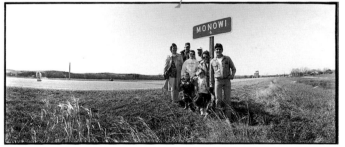

By Dennis Kitchen

Introduction by Garrison Keillor

CHRONICLE BOOKS, SAN FRANCISCO

Book design: Kiyoshi Kanai, assisted by Sayuri Shoji
Printed in Hong Kong

Library of Congress Cataloging-in-Publication Data:
Kitchen, Dennis.
 Our smallest towns / by Dennis Kitchen ; introduction by
Garrison Keillor.
 p. cm.
 ISBN 0-8118-0902-1
 I. Cities and towns—United States—Pictorial works.
2. Landscape photography—United States. I. Title.
E180.K53 1995
973'.09734—dc20

 95-4984
Distributed in Canada by CIP
Raincoast Books
8680 Cambie Street
Vancouver, B.C. V6P 6M9

10 9 8 7 6 5 4 3

Chronicle Books
275 Fifth Street
San Francisco, CA 94103

To my mom and the memory of my dad.

And to my darling Camille, with love.

Acknowledgments:

This book would not have been possible without the support, interest, and kindness of the following:

Marty Goldstein, Caroline Herter, Ron Hollander, the Kamuela Inn, Kiyoshi Kanai, Colin Lane, the Maui Westin, Sarah Malarkey, Bob Miles, the New York City Public Library, Al Shackelford, Harvey Stein, Chris Toliver, Umbra Editions, the United States Census Bureau, Liz Zazzi, my friends and family, my loving wife, Camille, and especially the subjects of my portraits—the public servants and citizens of our nation's smallest towns. Thank you.

—DK

Table of Contents:

Preface:

It happened in nearly every small town I visited. A look of puzzled disbelief would come over the faces of the townspeople as they discovered I had traveled all the way from New York City to take their picture. I'm not sure if it was a reaction to the great distance I had traveled, or if for many of them, I was the first person they had ever met from a city whose population exceeds seven million people. No matter what size town you're from, New York City takes some getting used to, and after fourteen years of happily living and working here I consider New York City my home.

I was born in Fargo, North Dakota, population: 74,000. My first glimpse of real small town life came from my grandparents. They lived sixteen miles away in the tiny rural town of Argusville, population: 161. My grandpa, a retired framer, had been Argusville's mayor for years. When he wasn't working at my dad's Tastee Freez in Fargo, he was tending to his mayoral chores back home. Once a year he would hook up the grader and climb aboard his tractor and level off the eight gravel roads that ran through town. It was fun when he'd let me and by brothers jump aboard to help him with the steering. I always got a kick out of driving past his town post office. Grandpa's post office was in his neighbor's house and except for the little sign next to the side door and the big flagpole in the front yard it looked like a normal house. I never looked inside, but as a youngster, it was hard for me to imagine a post office in there.

The idea to photograph the least populated place in each state presented itself to me in the winter of 1991. Much of that spring was spent doing research at the U.S. Census Bureau in New York City. The Bureau provided me with two key pieces of information: The name of the least populated place in each state and the local government office that could put me in touch with each of the town's officials. I sent letters of introduction to all of them and followed up with telephone calls. Most were receptive, some were wary and a few said no. I tried my

best to be true to the 1990 Census, but in some cases, the findings were already outdated. Many of the towns had grown, shrunk or dissolved since the figures had been compiled.

For me, part of the success of the town portrait was in the turnout. To a certain extent, the number of folks that showed up for their picture said a lot about the town, its people and its character. I am grateful to all the mayors, clerks and volunteers who motivated their townspeople to support me by participating in the town's group photo. The mayor and clerk of Grenville, New Mexico, population: 30, had a great idea. The ladies who run the town knew they wouldn't get much of a turnout if they asked its residents to turnout for a town picture so they tried something else. On the day of the town picture they served the entire town a free lunch at the Fire Station. Afterwards, all thirty town residents stepped outside to have their picture taken in front of the town hall.

The actual picture taking took very little time, usually fifteen to thirty minutes. Since the location and start time had been prearranged, it was just a matter of establishing the camera position and waiting for the late stragglers to arrive. All the town portraits in the book were shot with the Widelux 1500 panoramic camera and Kodak 120 T-Max 400 film. I generally worked alone and relied solely on the existing natural light for illumination.

Naturally the project took a little longer and was a little more involved than I estimated but I had a great time working on it. I've met some wonderful people and have traveled to some amazing places. I've also collected enough fond memories and tall tales to last a lifetime. I hope you enjoy the book.

Dennis Kitchen
Spring 1995

Introduction

When a small town gets so small that a photographer can round up all of its residents and get them into one close-up picture, you have a town small enough to be the punchline of a joke. As in the famous "My town was so small that nobody bothered to use their turn signals because everyone knew which way you were going anyway" type of joke. In a town this small, you have to learn to laugh at yourself: there is nobody else to do it for you. The bride has to sing at her own wedding and the groom has to hold the shotgun himself. A town so small is too small even to have one horse; it may only be a one-dog town, and the dog is thinking about leaving, because it is too slow for him there.

Life in a one-dog town is a different form of urban life, and it's worth thinking about. A town like Tenney, Minnesota, population seven, is more a family than a town, a family of unrelated people living in close proximity for reasons that aren't immediately apparent to the rest of us. They aren't farmers or hermits and have come to live in an intimate community, either by a long process of eliminating other possibilities, or by magic, or else because they were there and wouldn't go away.

When we imagine the small American town, such as Anywhere, U.S.A., where John Doe lives at 1234 Maple Street, we imagine a town of at least two or three thousand souls, with a water tower,

four or five church steeples, a 19th century Main Street with brick storefronts, a ball field, an old brick high school, a train depot, and hundreds of white frame houses with picket fences. The Does grew up in Anywhere, but still, there are plenty of people here who don't know them, and if John and Jane should start shouting at each other one evening and John stalk out and slip into Nowhere Tavern and sit despondent at the bar and knock back a few shots of All-Purpose Bourbon and come weaving back to Maple Street and find that Jane has locked him out of the house, he can find a motel to sleep in, and go apologize to her the next morning, and be taken back, and not everybody in Anywhere will know the whole story. In a one-dog town, it's different.

A town so small has precious few of the urban amenities and very little of the majestic privacy of life in the woods. You can't walk around the corner and find someone to cook your lunch for you or wash your clothes. There may not even be a corner to walk around. But everyone in town has seen your underwear hanging on the clothesline and heard you snore, and if you like bourbon, they know how much. And when you go to church and kneel to confess your sins, everybody else knows the sins you're thinking of and also which ones you're forgetting. They see the shoes you're wearing and think that they like the ones you wore last Sunday better.

These towns are monuments to the great American spirit of stubbornness. While the country as a whole follows trends, reads best-sellers, adheres to the current wisdom, and the population slips toward the cities and down to the Sun Belt like loose buckshot, some people simply don't do what everybody else does. Some people stick it out in Delphos, Iowa, though the store and lumberyard and grain elevator are gone, and the post office is about to close. In Tenney, Minnesota, they are down to three men, four women, and the United Methodist Church, but they aren't quite prepared to surrender even though the town is practically dead. Perhaps that is because Tenney means something to them.

As isolated as their towns seem to be, a Delphosite or a Tenneyan is apt to feel more connected to things than,

say, a New Yorker does, who would hardly dare dream that he or she could make a big difference in the city, whereas in a one-dog town, every time you mow the grass, it's urban renewal.

In a big city, it's easy to believe that the government is corrupt, and education is falling behind, and the church is pitifully irrelevant, and that society's decline is inevitable — there is evidence of decline, and the supposed inevitability of it justifies a person's abdication of social responsibility — but in a small town, you are deeply implicated in all institutions: If there is going to be a government, then you have to take your turn doing it, and if the gospel is going to be put forth, you're going to be the putter. In a one-dog town, citizenship makes you a leader automatically. You are on all committees, and you can't sit in meetings and hope somebody else will speak up; you are going to have to do it and, if necessary, speak the inconvenient truth. Without it, the town may go belly up. Of course you can always blame the county, but you know what you know: your neighbors depend on you. In a big city, criminals ply their trade in the open because honest citizens figure that reporting crime won't change anything and isn't worth the trouble. In a small town, any crime is a crime against you.

To outsiders, which we are, the one-dog town may appear vaguely silly and hopeless, a living failure, folks who didn't know when to give up the ghost and get with the program, but we may be wrong about this. Small-town people feel that they have escaped from the struggle for supremacy and found the secret of satisfaction. The philosophy of Good Enough, which is rare in mainstream America, is strong in the one-dog town. Elsewhere, people hate themselves for failing to be skinny enough, smart enough, sexy enough, rich enough, but perhaps in Tenney, Minnesota, which never will be the Athens of the Midwest, the Jewel of Wilkin County, or even the Queen City of the South Fork of the Rabbit River, you can feel you are a good enough person for normal purposes and that life is good enough as it is.

It could be worse. Someone could make an unsignalled right turn where he had always turned left and run over your one dog, and then you would have to talk another dog into taking his place.

GARRISON KEILLOR

Gannts Quarry, Alabama

POPULATION: 2

In the late 1800s a medical doctor by the name of Henry Gannt discovered stone on his farm. He sold the land, located at the foothills of the Appalachian Mountains, to a family in the marble mining business. Like a lot of cotton mill villages, the village of Gannts Quarry was formed because of the marble industry. At one time the population of Gannts Quarry was around five hundred, and virtually the whole town was employed by the marble company. There were two churches, a school, a store, and lots of houses. As time went on, people began to move away from their work and the town's population eventually dwindled.

Today, my wife Jane and I are the only ones left living on the original plant site. As mayor, I have two or three clerical obligations every year and that's it. Aside from being the answer to a trivia question now and then, we prefer to maintain a low profile as a town.

JIMMY REYNOLDS, SR.
Mayor

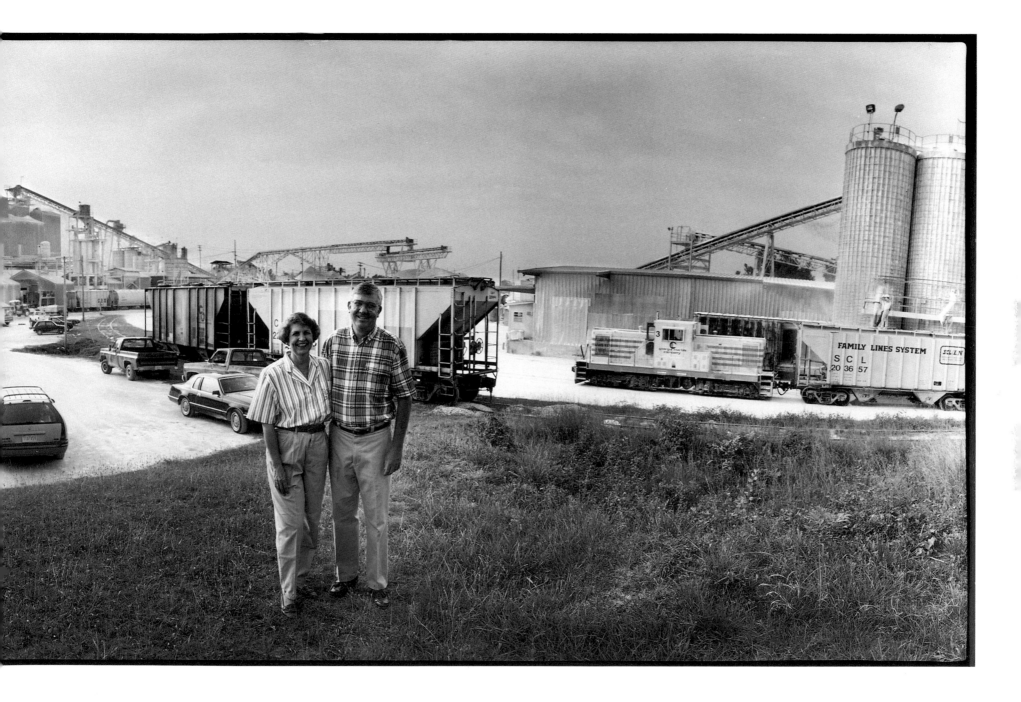

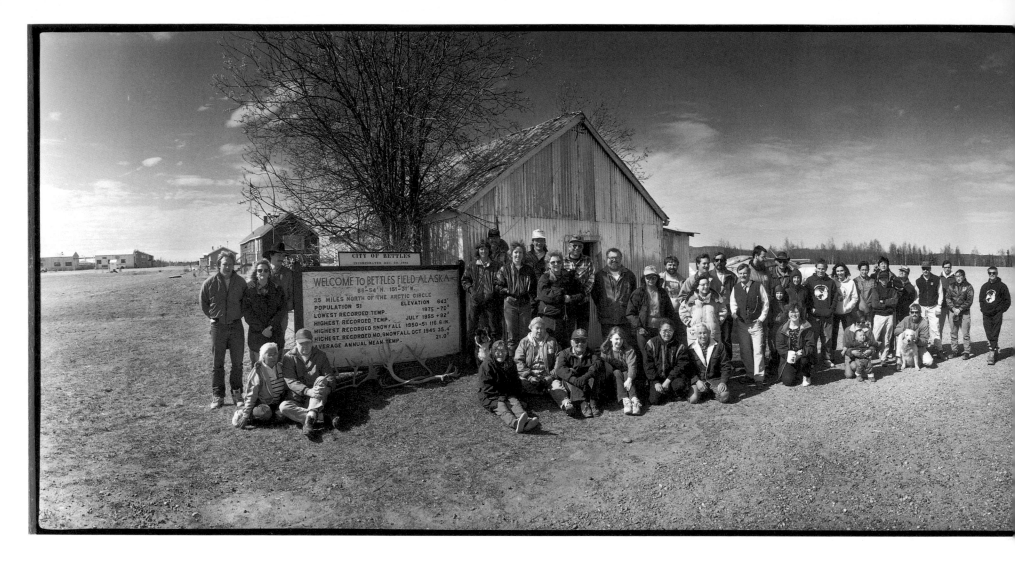

It was fifty-seven degrees below zero on the night of our wedding ceremony. Trek and I were married in the Comserfac (Community Services Facility) on January 20, 1993. We decorated the hall the day before with streamers and stuff that my girlfriend brought up from Fairbanks. We covered the pool table with my bed sheet because we ran out of paper tablecloths and put a big red bow on it. Everybody in town brought a dish of food to make it sort of a potluck thing. After supper most everybody left. At fifty-seven below, you don't want your snowmobile to break down and have to walk home. Back inside, the bathroom pipes froze up again and I was forced to go out the back door of the Comserfac in my mom's three-quarter-length backless lace wedding dress.

BOBBY JEAN THOMPSON *School Secretary*

Bettles, Alaska

P O P U L A T I O N : *50*

Gordon C. Bettles established a trading post here during the peak of the Alaskan Gold Rush in 1900. The town is located on the middle fork of the Koyukuk River on the southern side of the Brooks Mountain Range, approximately thirty-five miles north of the Arctic Circle. Most of the year, the only access is by air but you can arrive by water if you have a small enough craft. In the winter, we have an ice road that we can plow to the main highway if we're lucky. Around Christmastime the sun will hit the horizon at noon and then drop back down into darkness. There's maybe three hours total of light. As a community, we schedule group dinners together to avoid depression due to the lack of daylight.

GEORGE NICHOLSON *Mayor, School Principal, Teacher*

Jerome, Arizona

POPULATION: *402*

Jerome is a mine town. It's propped on a thirty-degree mountainside five thousand feet above the Verde Valley floor in central Arizona. Spaniards came here in the 1500s because they heard rumors of rich copper deposit. The first claims from diggings were filed in 1870. Eventually these diggings grew into one of the greatest copper-producing mines in the world, and the mining camp grew into the town of Jerome. In the early 1870s, Arizona governor Tritle agreed to name the town after New Yorker Eugene Jerome if he agreed to put up the money for a new mining camp. The town was incorporated in 1876.

PHILLIP TOVRE *Mayor*

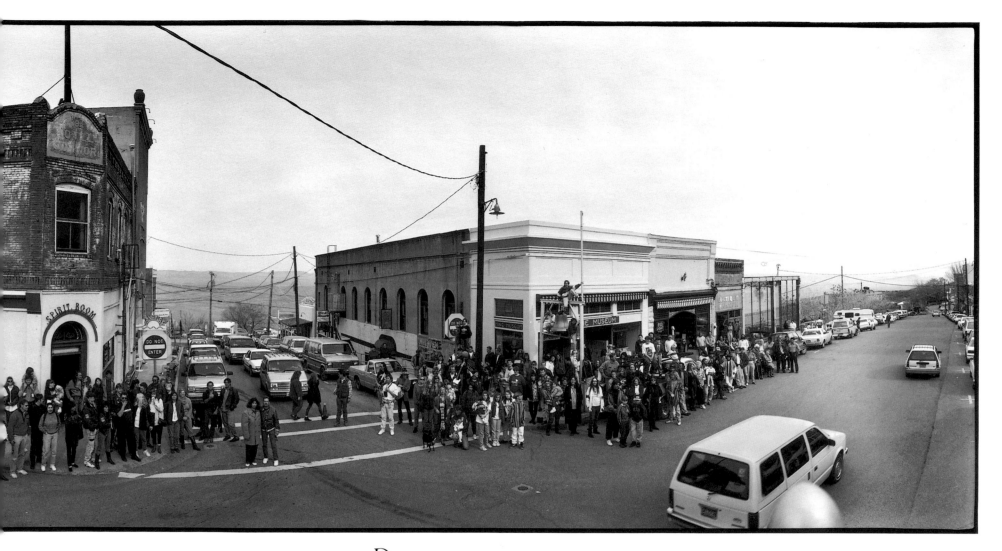

Dad named my older sister Billy because he always wanted a son. When I came along Billy decided I should be called Jimmy. My real name is Geraldine but everybody knows me as Jimmy. We moved here from the desert when I was four in 1917. I started teaching here in the fall of '35 and after forty years, I retired in the spring of '75. I've seen a lot of changes here in my life. Would you believe over fifteen thousand people lived here during World War I? Our drop in population is mostly due to the closing of the copper mine in 1953. Lots of folks left town after that in the 60s and 70s. The remaining residents survived by promoting Jerome as being the largest ghost town in America. We made our own road signs and built our own mining museum. Most of the folks who left come back one night a year and throw the town a big reunion party. "Spook Night," as it's fondly referred to, is the social event of the year.

GERALDINE "JIMMY" THOMAS *Town Resident*

Blue Eye, Arkansas

POPULATION: 34

The common theory of how the town got its name stems from the fact that the original founding postmaster had a daughter with one blue eye. We are unique in that we sit on the Missouri/Arkansas state line. One side of the street is Blue Eye, Arkansas, the other, Blue Eye, Missouri. The town was formed on the Missouri side in the 1880s but as people moved in, the town limits spread out. Spread so far it crossed the state line into Arkansas. In doing so, we incorporated in 1931 into a separate town in a separate state but kept the same name.

We do our share of hot rodding, you know; it's been going on here for years. Here on the line, kids will cut up and spin their wheels, then scurry over the boundary to the other side. It's a game they play with the deputies, because the state line prevents the local law enforcement from doing anything about it. It's just something you live with in a small town.

KENDAL HOWERTON
Mayor

I do colors, cuts, perms, nails, and suntanning. Since there's only me and the gas station and no barbers in town, I do a lot of men's hair too. For most of them, it's the first time a woman ever cut their hair. I charge the men five dollars for a haircut and the women eight dollars. Most days I'm here seven in the morning till eight at night. Most of my customers come from a twenty-mile radius to see me. When I'm not working or with my husband and family, I'm shopping at Wal-Mart, where else?

REBECCA CULP
Owner, Hair Peddler Beauty Salon

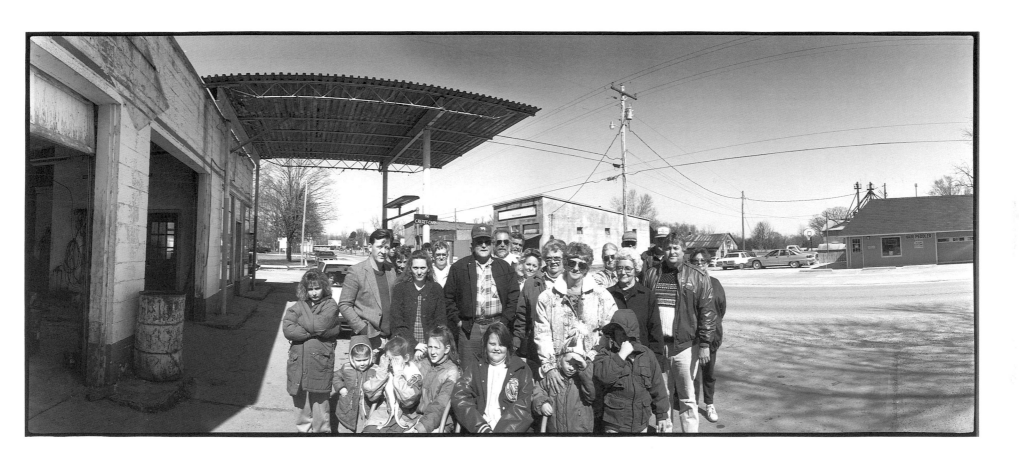

19

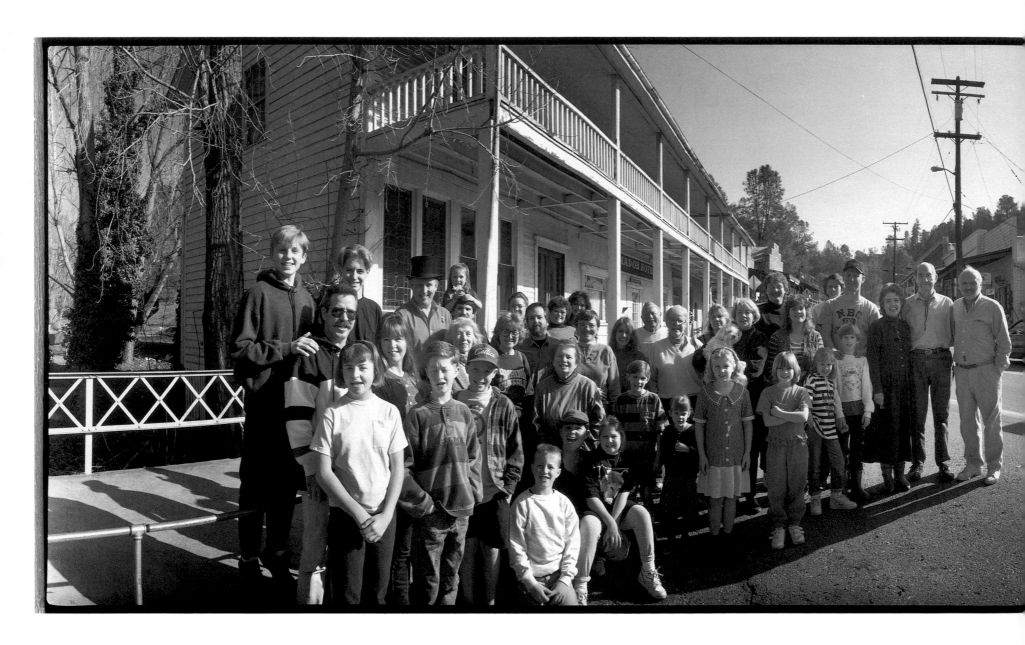

Amador City, California

POPULATION: *188*

José Maria Amadore and his Indian slaves took gold from the creek one mile east of here in 1848. This whole area owes its existence to the Mother Lode, and to the "gold seekers" who by various means managed to get here in 1850 from all over the world. A great many residents in town descend from these original immigrants, which can lead to all sorts of complicated family relationships. It's enough to drive a genealogist crazy and, hopefully, deprive a gossip of character assassinations, only because whomever they are speaking to is probably related to whomever they are speaking about. It's not uncommon for one or two generations to move away and subsequent generations to return here to live, like me. I returned fourteen years ago and bought a place here. As a child, I used to spend all of my summers and holidays here with my grandmother. It's always been unique here. It's become a tiny envelope of unspoiled beauty, resistant to change, standing still in time. It sounds Pollyanna, but it's true: Amador City is a wonderful place to live.

HOPE CHURCH LUXEMBERG
Town Resident

Bonanza, Colorado

POPULATION: 8

From what I've been able to find out, when they first hit gold in some of these mines up here, people down in town called it a bonanza. When this place was incorporated in 1892, that's what they called it.

EDGAR CARPENTER *Town Treasurer*

A few years ago, it started to feel a little empty around here after two of the six town residents died within a month of each other. Ed and I realized that the future of the town was at stake. Their passing marked the beginning of our campaign to get new residents to move here. It wasn't easy. Bonanza is 9700 feet high up in the mountains, and our winters last from November to April, sometimes longer. We tried for two years and nothing worked. Then one day, out of the blue, the town had a chance to get ahold of some properties at a very reasonable price. We decided to buy them and use it as an incentive for people to move here. We offered the lots to anyone who was interested in becoming a permanent full-time resident. We would sell it at a rock bottom price and space the very low payments out over a period of four years. If they stay and make all the payments, the land is theirs.

Needless to say, the campaign was a huge success. Mike, who begins serving his first term as mayor in April, was the first to move up here. He was followed by Dave, Toni, Greg, Bryan, and Daveen. They're equipped to vote, conduct town meetings, and transact town business. Ed said he's glad the promotion worked. After ten years as town treasurer, he said he was almost to the point of buying the land himself and just giving it to them to stay so he could find someone else to take over his job.

GAIL HOLBROOK *Town Clerk*

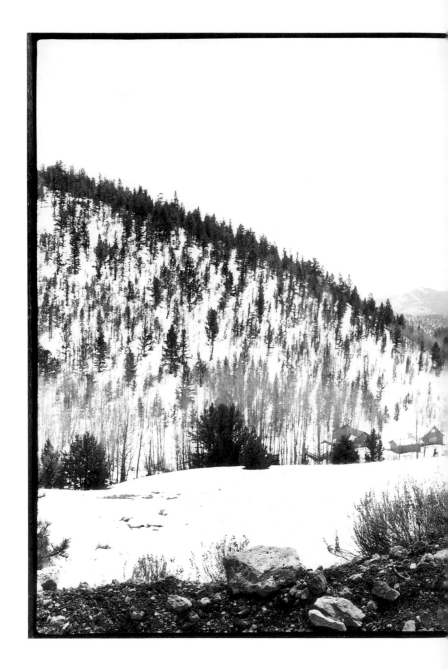

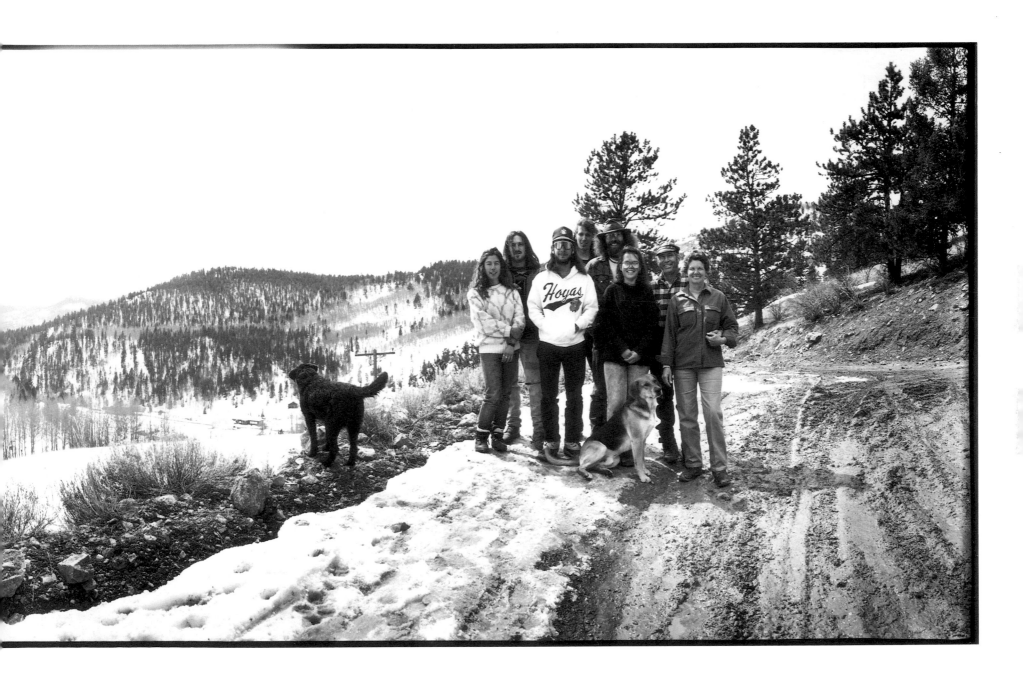

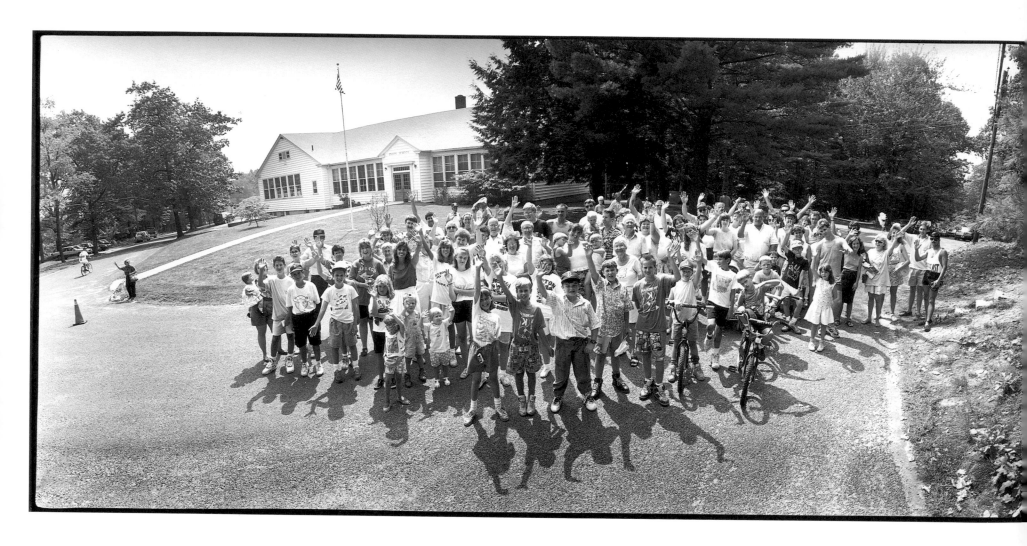

Union, Connecticut

POPULATION: *613*

Union was the last town settled east of the
Connecticut River in 1734. Since this was one of the last towns to be incorporated, it was made up
of, or formed the union of, land left over from one township and also land left over from another
township. This land was joined together to form the town of Union.

RAY BRADRICK *First Selectman*

I live in the same house my father grew up
in. My kids grew up there, too. We raised them to appreciate the nature here. Now they know just
about every inch of this town because they've walked it. They acknowledge the flowers and birds
and the wildlife that surrounds them. You cherish the little things because you can get up
in the morning and see the most beautiful sunrises through the trees. Union has given us a good
clean life. It's really a joy to live here!

JANICE PARSONS *Third-Generation Resident*

Henlopen Acres, Delaware

POPULATION: *106*

In 1929, Wilbur S. Corkran acquired this one-hundred-acre homestead for the sum of $100,000. Over the next three decades, he transformed it into a residential community of abiding beauty. It was his intention to gradually develop this oceanfront farmland into a second-home cottage community. Fifty-five of the 173 homes here are occupied all year round. Most of the full-time residents are retired people who used to spend their summers here. Besides the housing lots, Henlopen Acres has land set aside for the marina, the town hall, the beach club and the Rehoboth Art League. The Art League, founded by Mrs. Corkran, is headquartered in the original 1743 homestead, a building of landmark status and national prominence. Today, Henlopen Acres is estimated to be worth $20 million.

WALTER DEAKYNE, JR.
Mayor

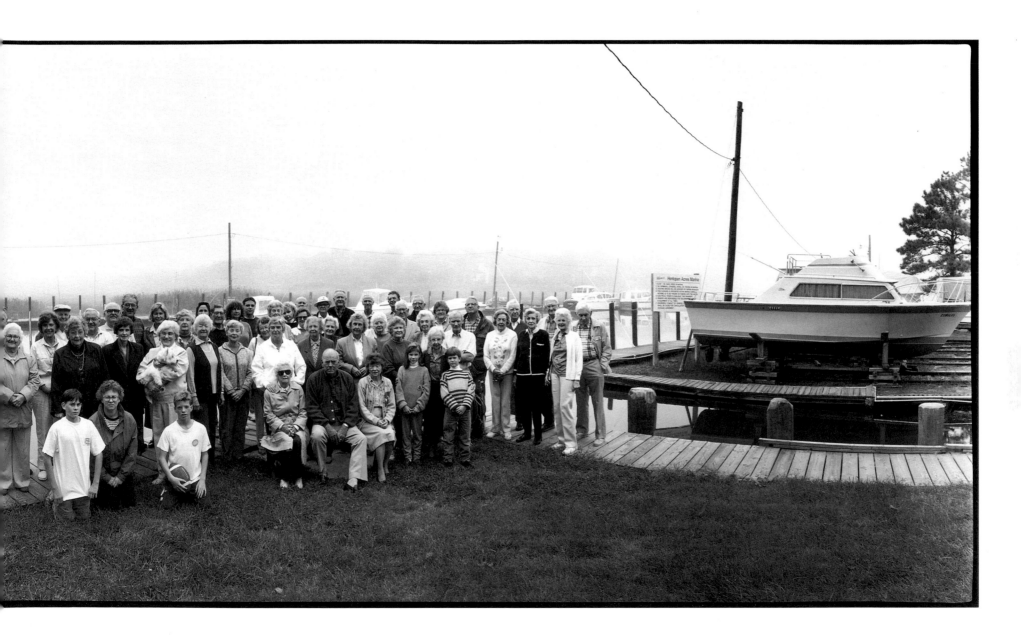

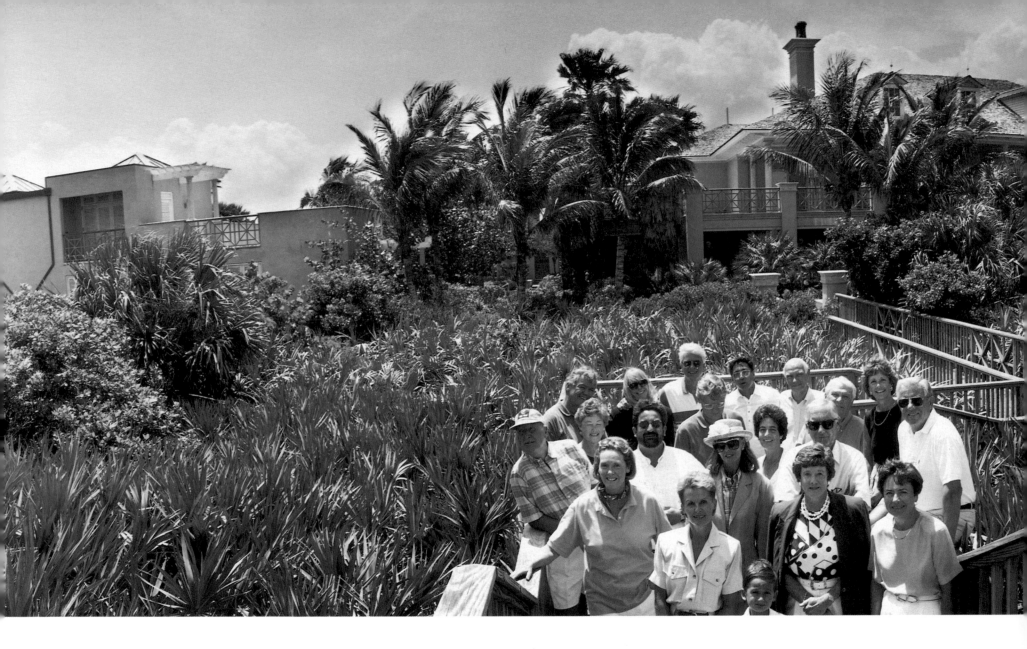

Orchid, Florida

POPULATION: *19*

The town of Orchid is a 750-acre island located 150 miles southeast of Orlando between the Atlantic Ocean and the Indian River. Prior to its incorporation in 1988, the island was a family-owned citrus grove, home to the world-famous Orchid Isle/Indian River Grapefruit. This is our California-style Beach Club and Community Center. Arnold Palmer designed the eighteen-hole golf course across the street where the citrus groves used to be. Currently, we have a dozen houses built, with room for as many as three hundred. As a gated community, we have a nonresident town manager, town clerk, security staff of twelve, and an extensive ground-maintenance crew.

TED LEONSIS *Mayor*

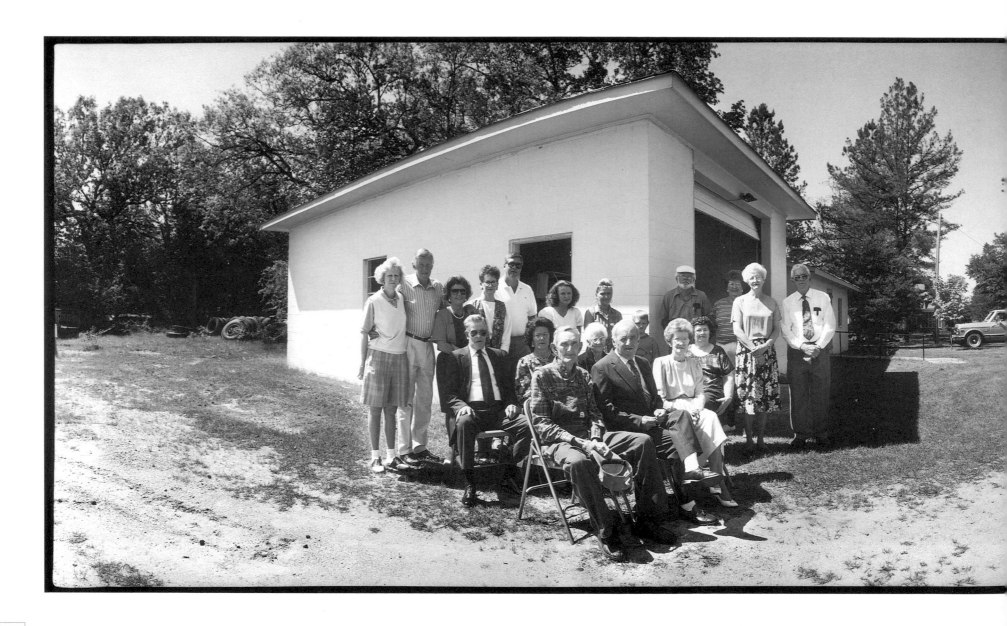

Edge Hill, Georgia

POPULATION: 22

I'm not entirely sure how the town got its name.
I've only lived here thirty-nine years, but I believe one of the early settlers moved down here from Edge Hill,
Virginia, and brought the name with her.

This year our charter, which dates back to 1839, was nearly
revoked by the state of Georgia. It seems a town must provide at least four services for its townspeople and all
we provided was three. We have street lights, city water, and a fire truck. We were all real upset, but no one
knew what to do about it. Then someone suggested we buy a trailer for folks to throw their garbage in. That
didn't work, so now my husband, a town councilman, goes house to house in his pickup and collects it. Every
Tuesday he makes thirteen stops. Everyone sets the garbage out near the mailbox. That's how he knows to
pick up. The landfill's 4 1/2 miles away in McPuffy County, where we have a garbage contract for
two dollars a month.

GLORIA HAWKINS
Mayor

Kukuihaele, Hawaii

POPULATION: 97

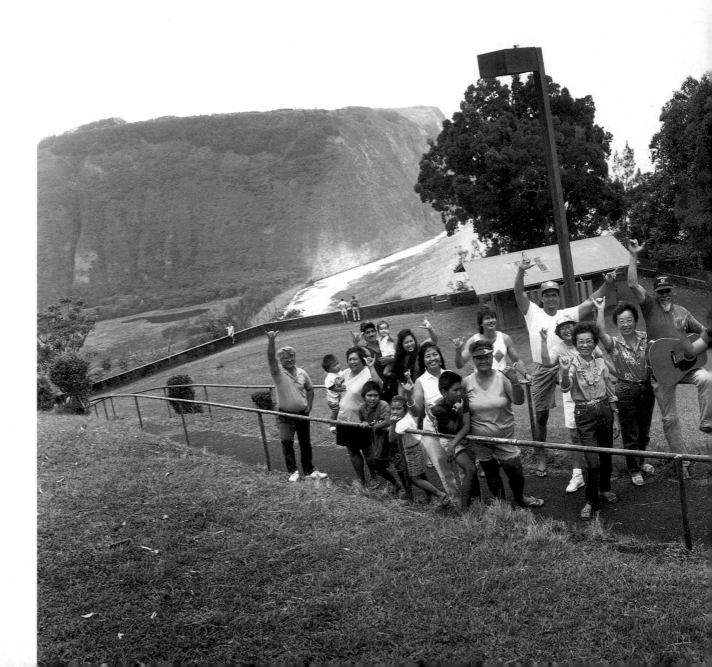

The Waipio Lookout behind us means "Valley of the Kings," and long before the sugar plantations inhabited this area we were one of the imperial centers of the Hawaiian Kingdom. Our poor showing today is a reaction to a proposed resort development that has divided our community. Supporters of the development welcome economic growth and new jobs, while the others feel it will raise property taxes and infringe upon their native lifestyle.

Shaka is an upbeat Hawaiian expression and gesture. We use it all the time. It means many things—a greeting, a cheer, a recognition—but mostly it means "everything is great." *Shaka!*

TAKASHI DOMINGO
Councilman

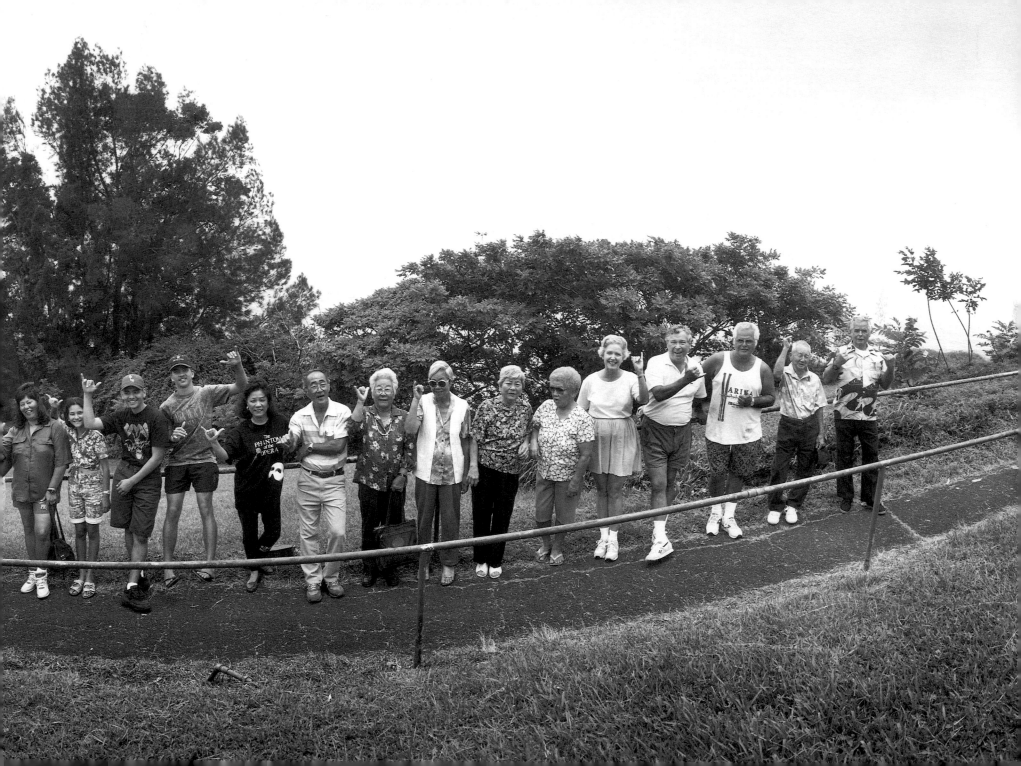

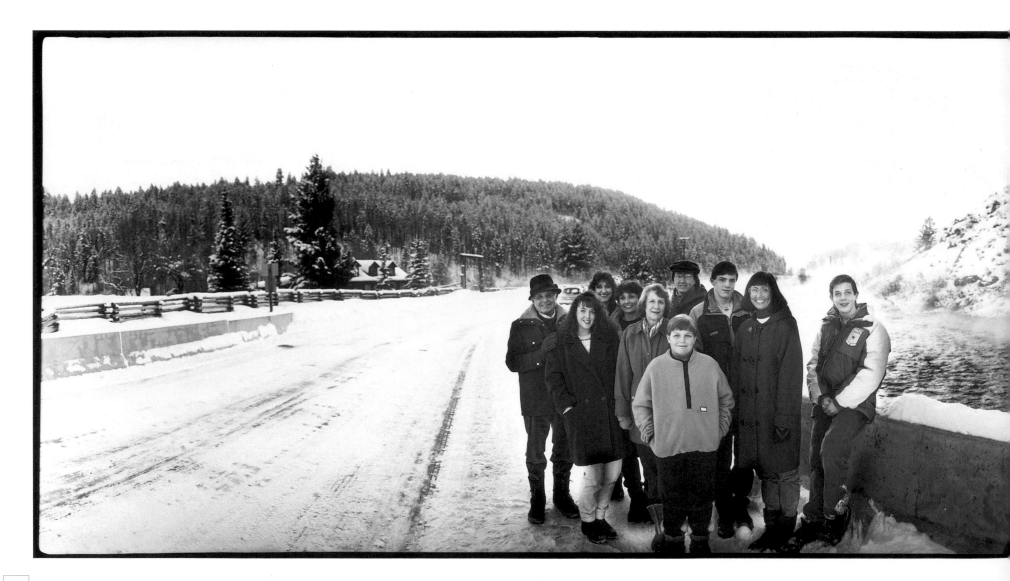

Warm River, Idaho

POPULATION: *11*

The village was named for the stream that flows through this canyon. The stream is called Warm River because the water always stays fifty degrees and never freezes. Like the town, the guest ranch is a Lewies family operation. I've lived here my entire life. In fact, my parents homesteaded this land in the 1920s.

When it comes to sportfishing, we encourage our guests to adopt a "catch-and-release" philosophy. The thrill is in the hunt and once the fish is hooked, it's gently released and returned to the stream. Preservation is practiced here because the Warm River is a spawning river for German brown trout.

We're situated high on a mountaintop and look down into the Robinson Creek as it flows out of the Yellowstone Park. In the distance, you can see the peaks of the Teton Mountains of Wyoming. Lately we've been feeling the pressure of spillover from these surrounding recreational areas, but as you can see, we have no interest in condos and marketing and development. Our main interest is preserving the solitude and beauty of Warm River and its natural surroundings.

HARRY LEWIES *Resident*

Valley City, Illinois

POPULATION: 23

The mayor and I have been married fifty-seven years next month. We've lived here our whole life and even some as kids before that. We've been here so long we're related to everybody in town in one way or the other. First, of course, there's Delford, my husband; everybody calls him Ted. Then there's Mary and Larry who own one of the taverns. Larry is the town board secretary and Mary is my daughter. Next there's Butch and Jody. That's my youngest boy and his wife and their little girl. They live in that other trailer down there. My other grandson lives up here in the house just as you go out of town. That's him and his wife. They have three girls. Carol and her husband, the big guy, and their kids live up here in this trailer over here. Her mother is Larry's aunt. Finally there's Patty, my oldest, with her granddaughters, whose dad is her youngest boy Bobby. That's the whole town except for nobody's related to the guy who runs the other tavern.

Aside from the two taverns and a gravel pit, the other business in town is our cheese factory. My granddaughter works there. They make good cheese, and the taxes they pay help out the town. Living next door isn't always so good. Whenever it rains and you've got your windows up, you can smell it from the sewer. They're nice people though; every year they come around through town and give you a five-pound box of cheese for Christmas. It's not sliced.

If it was, it would be so much nicer.

ADA TOOLEY *Town Clerk*

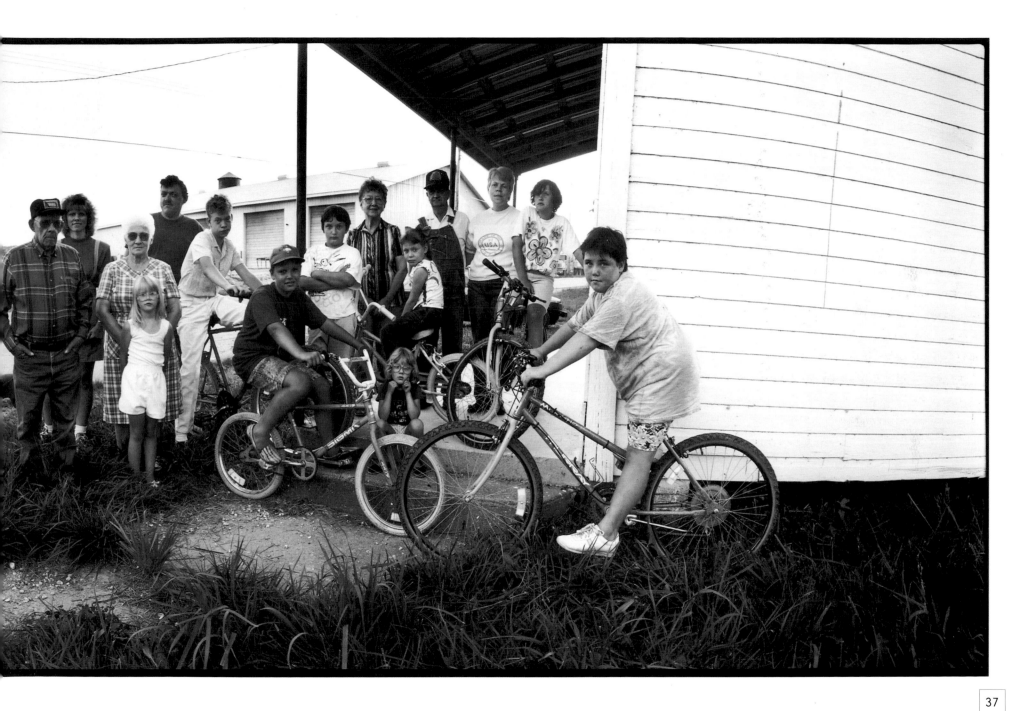

New Amsterdam, Indiana

POPULATION: *30*

There hadn't been a town election in New Amsterdam in over forty years. The issue was over a problem we were having with a loose dog that was running around out here. What happened was the dog bit a three-year-old girl about a mile down the road from here. After hearing the complaints, the town board asked the owner to tie up his dog. Not only did he not tie up his dog, he challenged the mayor to run against him in the upcoming election. This was a first. As far as anyone could remember, town officials always ran unopposed in New Amsterdam. We hadn't had an election here in so long, I spent nearly thirty dollars in long-distance calls to the state election board in Indianapolis to make sure we were doing everything legal. Imagine having to have a six-member town election board sitting around up there from six in the morning till six at night waiting for twenty-four eligible townspeople to cast their votes. The six-hundred-dollar election bill ate up our general fund and put the town way into debt. By law, we had to hold that election even though we couldn't afford to. Needless to say, my husband Brett, the incumbent mayor, was reelected by a vote of sixteen to eight. The loose dog was put to sleep.

The little girl that was bit is doing just fine, and the man who lost hasn't spoken to none of us since the election.

MARY FAYE SHAFFER *Clerk/Treasurer*

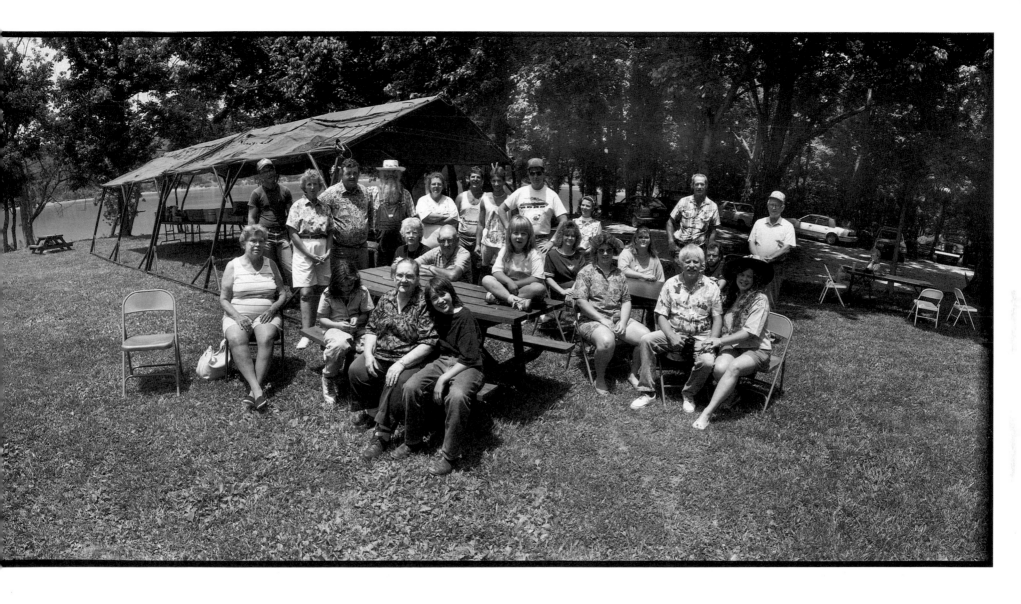

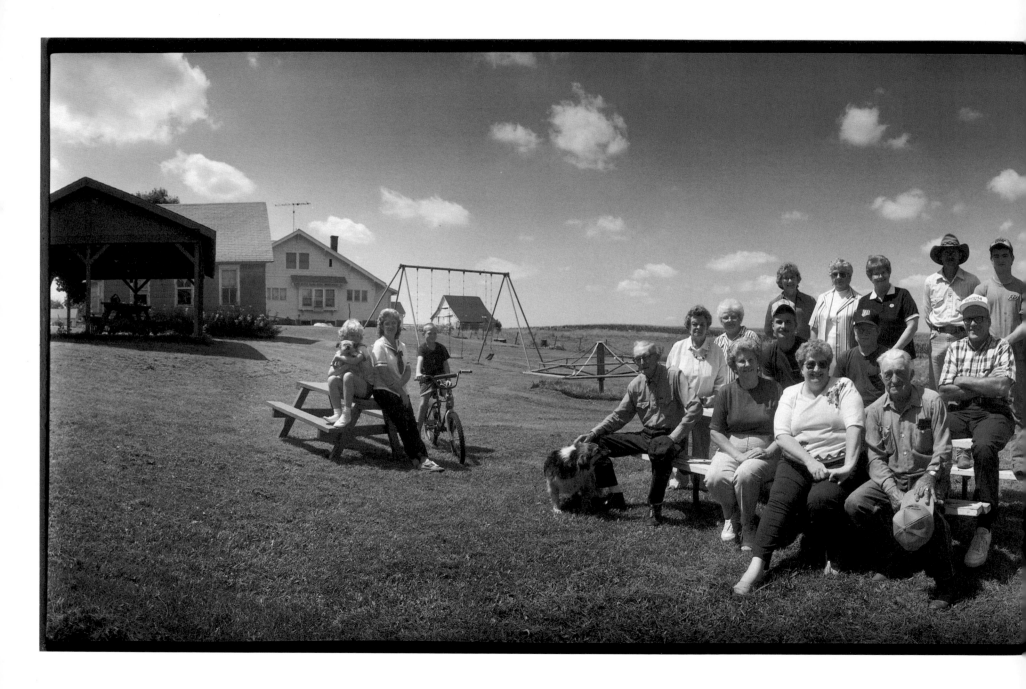

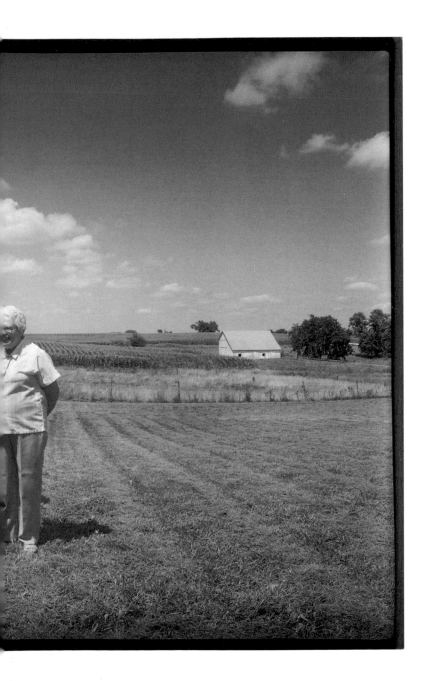

Delphos, Iowa

POPULATION: *18*

No crime here. Just dog killing. People bring dogs out here to the country and dump them. This ain't no dumping ground. It's our town, and it happens a lot more than it should. Last night I seen a pack of dogs running around out back of here. I've killed several. I'll admit to that. I'm a farmer. I've got sheep and cattle around here and I won't put up with it. The sheriff said just catch 'em and have them put to sleep. And I said a four-ten will put 'em to sleep a lot easier. It costs six or eight dollars apiece to put them to sleep. I figure I save the county money by doing it myself.

Delphos, which means brother, was platted in 1880 by the C. B. and Q. Railroad. Back then there was a blacksmith's shop, a shoe cobbler, a lumberyard, a grain elevator, a boardinghouse, a general store, a church, and the post office. Last two are the only things still standing. We're on borrowed time with the post office. They've been two years at closing it. They say it'll come down within sixty days. It's not a paying proposition anymore.

RALPH BRAMME *Mayor*

Freeport, Kansas

POPULATION: *11*

We left so many wonderful friends back here I'm just thrilled to pieces to be back home again. We moved away and have spent the last thirteen years in New Jersey. My husband, Russ, who is the pastor here used to spend four hours a day commuting back and forth to New York City. Since moving back he likes to say he can kick clods all the way and still make it home in less than two minutes.

As you can see, the town is just a small portion of First Presbyterian Congregation. There are more people that belong to the church than live in the town. The official population count says ten people but we claim eleven because Jim's daughter is away at seminary in Dubuque.

JOYCE JOLLY
Mayor

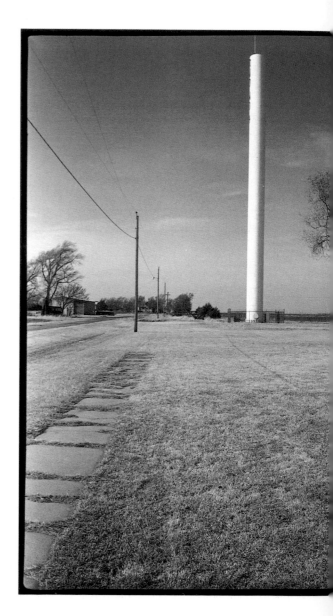

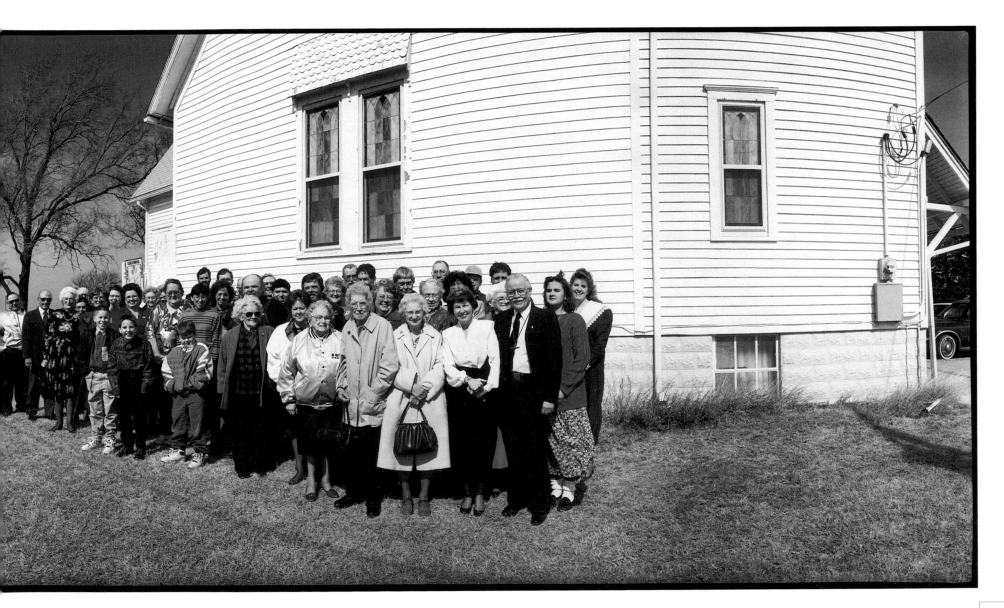

43

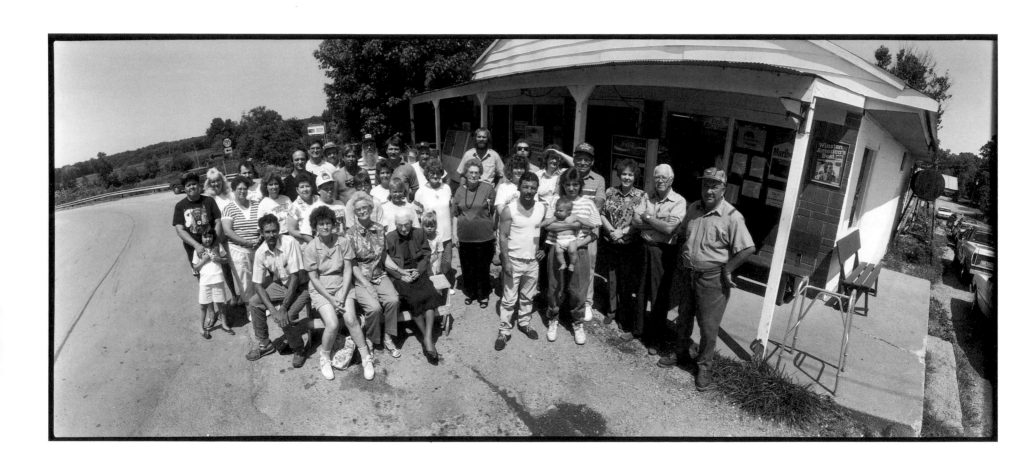

Dycusberg, Kentucky

POPULATION: *41*

Dycusberg is the most colorful place one can imagine. In 1831, Barry Dycus started the town by building its first shipping warehouse. For years the Cumberland River was the town's greatest asset. It was the number-one means of shipping tobacco from here to the surrounding cities of Paduka and Nashville. Back then it was an exciting, thriving, glamorous river town with hotels, stores, warehouses, and saloons. It even gained a rough reputation because of all the characters that landed here. Today the occasional passing riverboat is still a source of interest. It never fails to fascinate me as it drifts by, and I always stop what I'm doing to pause and admire it.

One look around and you'll see that our sleepy little village moves at a much slower pace than it used to. Did you ever take a fishing pole with a cork and just sit on the river bank and relax? Try it sometime. The worms are a bit squirmy, but the overall thing is worth it. My husband Mutt fishes down at the river every day. He's caught nearly four hundred catfish this spring and hopes to get one hundred more by the end of the summer. Mutt's supplying all the fish for the Dycusberg Fish Fry and Potluck Dinner. It's the town's way of raising money for the cemetery's increased maintenance costs. We hope to serve seventy-five people or more. Why don't you join us? You don't have to be from Dycusberg to be welcome.

MARY LOU GRIFFIN
Town Resident

Downsville, Louisiana

POPULATION: *101*

I'm happy to see such a great turnout for the annual town cleanup day. I think nearly everyone in town showed up. Let's see, there were the Boy Scouts, the Girl Scouts, the Brownies, the church groups, the school faculty, and many more. We all met early this morning in the center of town at the park and split up into four groups. We only have two roads and they intersect back in the center of town, so each group is taken out about a mile in each direction. Next they all walk back into Downsville on both sides of the road picking up the trash and bagging it. The whole thing takes about 2 1/2 hours, so we topped it off with a free town lunch at the Downsville Hall. We ate hot dogs, shared devotions, and passed out complimentary T-shirts.

In honor of W. Solomon Downs, Lower Pine Hills, as it was originally known, was given the new name of Downsville when it was incorporated back in 1851.

REGGIE SKAINS
Mayor

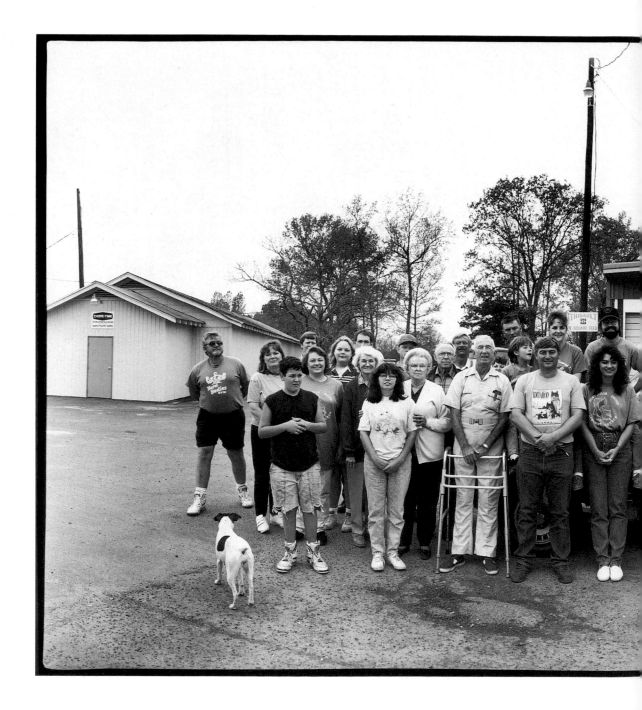

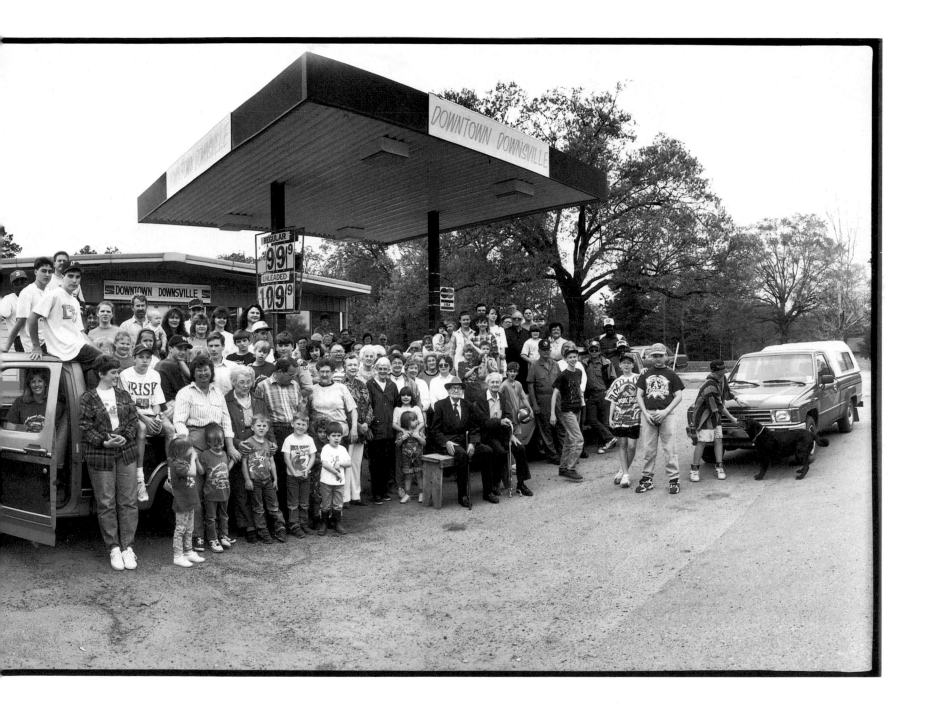

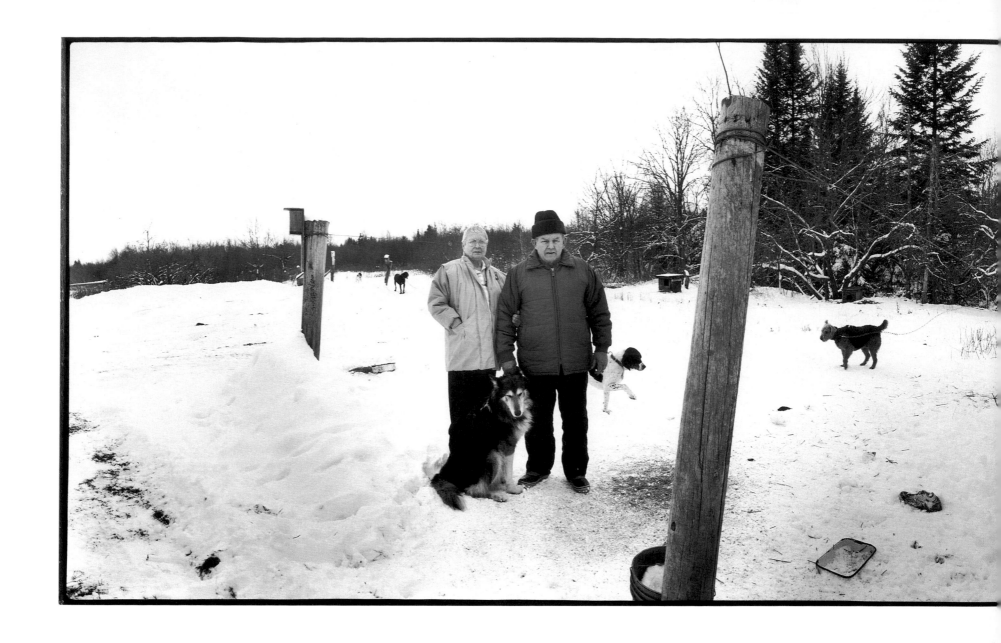

The town was settled by Seth Spalding in 1863. There were over four hundred people here at the turn of the century; most of them were involved in the lumbering trade. In 1940, all that changed when the old-timers of the town said no to electricity. Said they couldn't afford it. Now most everybody's grown up and moved away to where they can find electricity. Joe and I turned down electricity in 1956. We would have had to set our own lines from here to Patterson Hill and pay sixteen dollars a month! We said we'll light the house with a lantern, thank you. We use a gas stove and refrigerator and watch battery-operated television. The house is heated with a wood-burning furnace in the basement. It gets so warm in the winter that we sleep with two windows up and the back door wide open.

EVELYN AND JOE MACDONALD
Town Clerk and First Selectman

Glenwood Plantation, Maine

POPULATION: 2

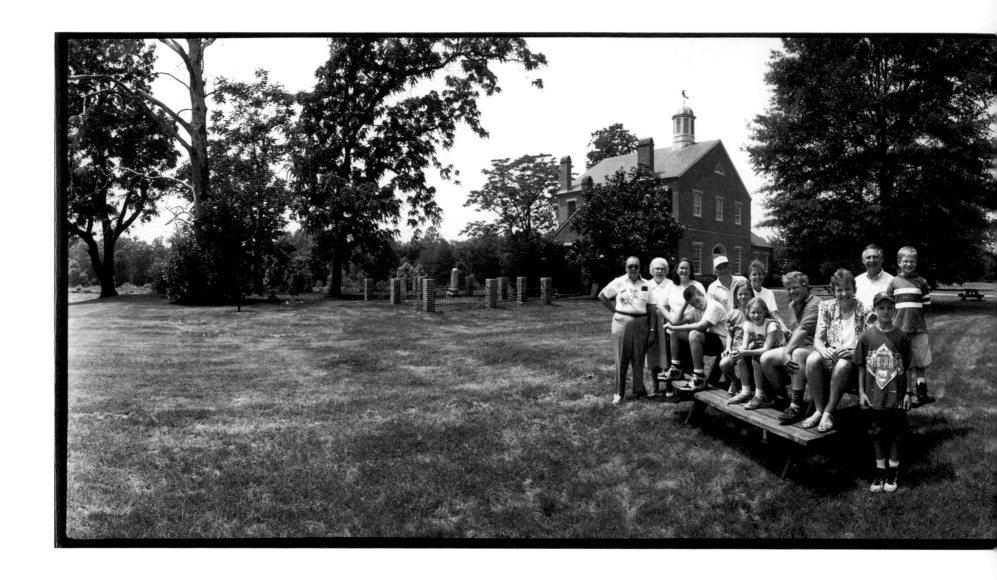

Port Tobacco, Maryland

POPULATION: *21*

The town's name has nothing to do with tobacco, even though it's the most important crop in the county. The name is actually a corruption of the Indian name Portopaco, which means "a place within the hills." Our history dates back to the mid 1600s, when we served as a major naval port until the end of the Revolutionary War. After Lincoln's assassination in 1865, John Wilkes Booth was hidden here for over a week with the assistance of a Confederate sympathizer. The reconstructed county courthouse of 1819 rests behind us and is a wonderful museum open to the public from April to December. Aside from that, there are only seven homes, all on the National Historic Register, that make up the town. We're just a quiet little village rich in American history that most folks drive past without ever noticing.

ROBERT T. BARBOUR
Town Resident

Gosnold, Massachusetts

POPULATION: *42*

We were settled in 1602, five years before Jamestown and long before the Pilgrims in 1620. An explorer named Bartholemew Gosnold sailed over from England with thirty-two men and colonized our island. The township of Gosnold includes all four Elizabeth Islands. The only occupied island is Cuttyhunk, located here in Vineyard Sound, 14 1/2 miles off the mainland coast of New Bedford, Massachusetts. The island is 2 3/4 miles long by 3/4 mile wide and all of the land is privately owned. There are forty-two year-round residents and as many as four hundred people in the summer. We have a post office, a library, an ecumenical church, a town hall and a seasonal inn/restaurant. Most of the island residents call the grocery store in New Bedford and the food is sent over by ferry, which comes daily in the summer and twice weekly in the winter. The seaplane flies until its pond freezes over and resumes when it thaws in the spring. It takes a real individualist to live here all year round. You can't go to the store, can't buy liquor, can't go to the movies, can't even get your hair cut—without taking a boat!

CHARLES TILTON *Selectman*

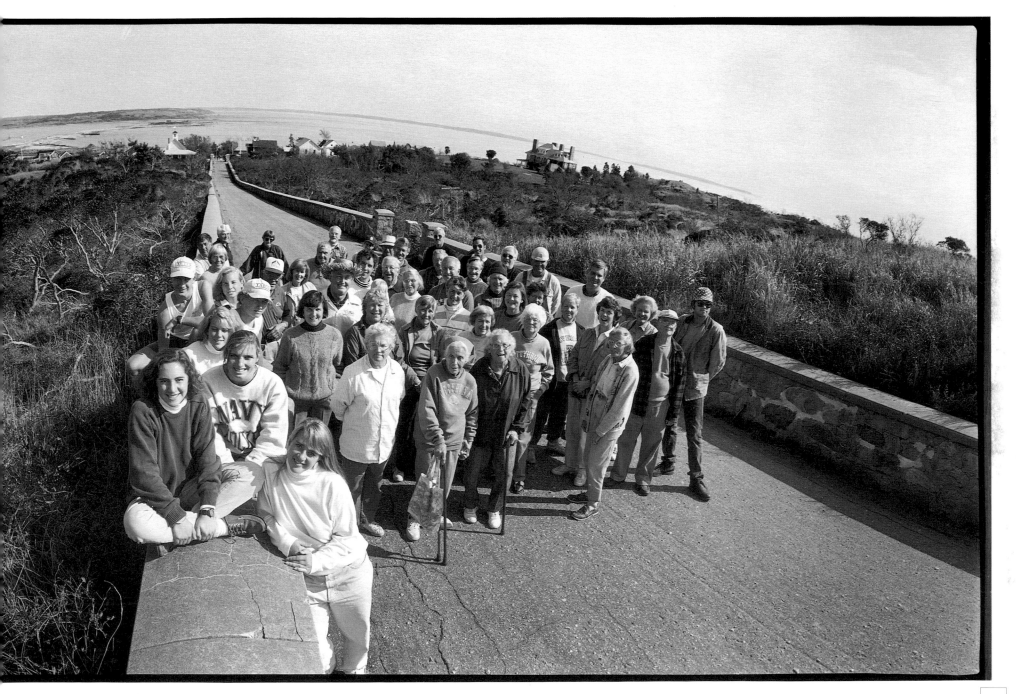

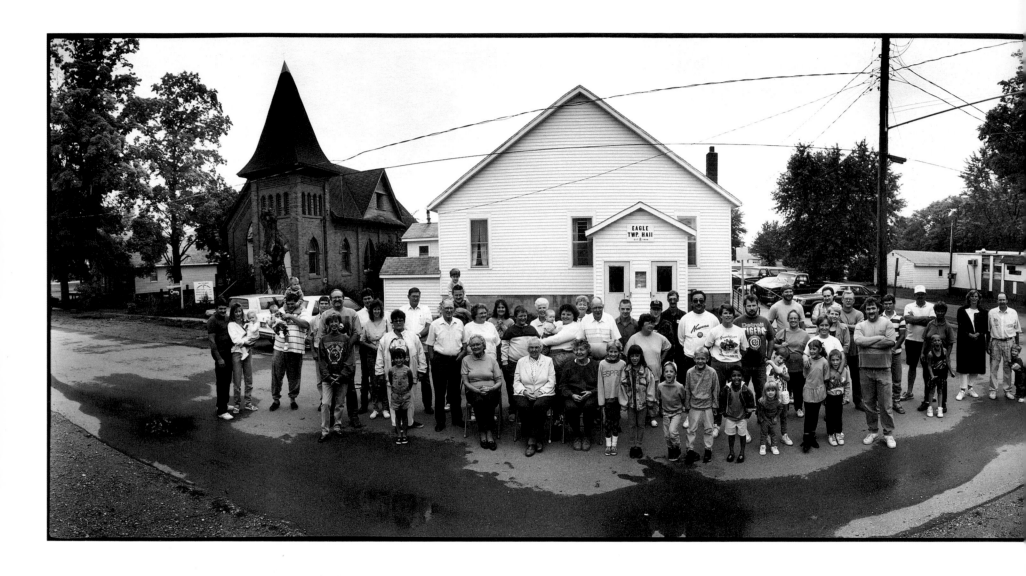

Eagle, Michigan

POPULATION: *103*

We just fought a battle to keep pornography out of the village. It started when the town board wanted to know who bought the abandoned Stucky's building. Our attorney looked it up for us, and we were all shocked to learn it was Lansing's King of Pornography. He wanted to open a roadside pornography store right here in Eagle. He figured when the truckers pulled off the 96 exit ramp he'd be there to catch them. We saw one of these places in Wisconsin. It was daytime and we could read the signs that said it was an X-rated bookstore. Do you believe the parking lot was packed full? The board wasted no time in calling an emergency meeting. We passed ordinances and declared his septic tank unfit. We found a gas leak in the old storage tanks, and the court ordered him to dig them up. We threw more obstacles at him than he could handle. He began to get the message, and I hope the battle is behind us now. Throughout this mess we got letters of support from people all over the country. I'd like to send a word of thanks to every one of you who stood behind us.

MILDRED COOPER *Town Clerk*

Eagle was named by David Simmons in 1830. He named it for his father who moved here from Eagle, New York. George W. McCrumb founded and incorporated the village in 1873. McCrumb was responsible for issuing bonds amounting to $9,500 for the purpose of assisting the opening of the Ionia and Lansing Railroad.

HELEN McCRUMB SMITH *Eagle Schoolteacher, 1929–1968*

Tenney, Minnesota

POPULATION: 7

We moved here in the 1950s with the girls because of the church. I used to be the pianist, but since my eyes got bad, I don't attempt it anymore. We're too small to have our own minister so we share one with two other churches. Our service doesn't start until 3:00 P.M. on Sunday because Pastor Flink has to make two other stops before he gets here. The big social event, our annual Tenney Day, is put on by the United Methodist Women's Club. It's usually held right after Memorial Day, when former people come back to celebrate and renew old acquaintances. It takes place in the house across the street in our Fellowship Hall. This year we had sixty-some people, but most years we have over a hundred.

The town was named after John P. Tenney because of his willingness to give land to the Great Northern Railroad as it came through here in 1885.

ALMA BERTSCH *Mayor*

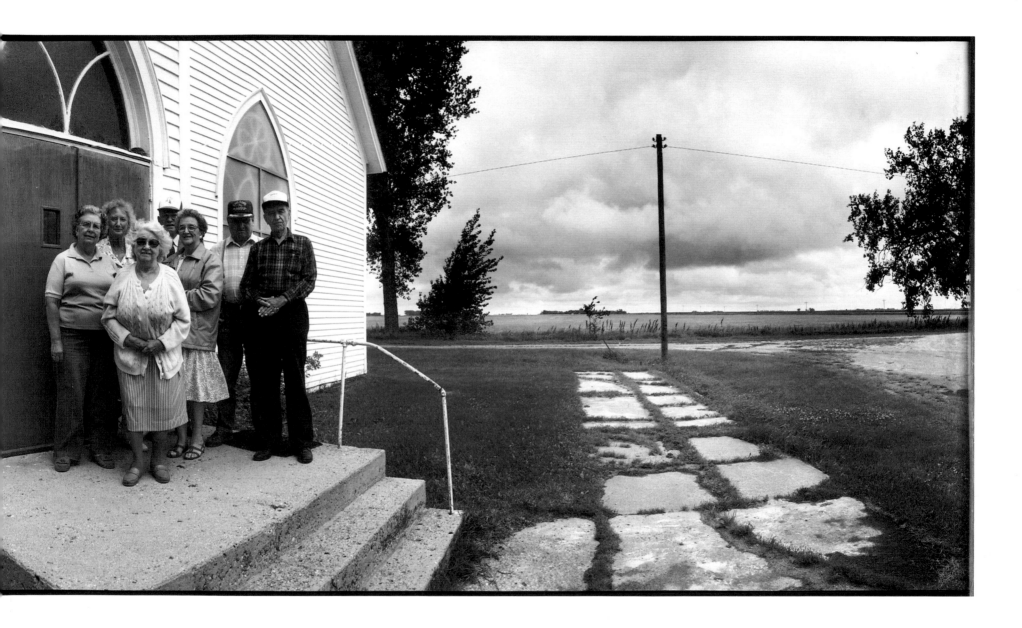

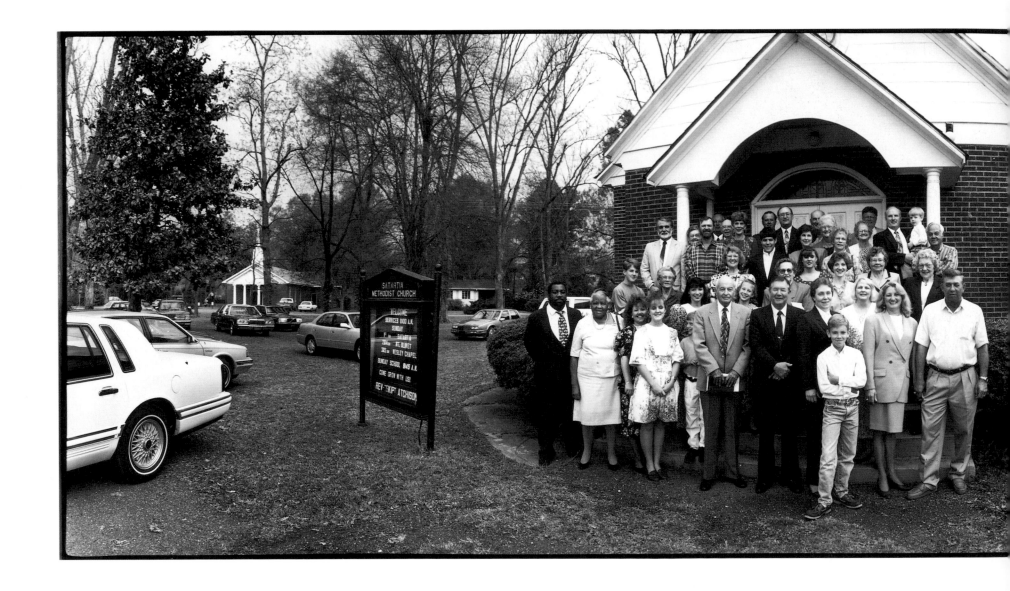

Satartia, Mississippi

POPULATION: 58

The colored church is around the corner. This is the Methodist here, and that's the Baptist back over there. There ain't but one God, you know. It ain't no black God and it ain't no white God. We's all prayin' to the same one. Been here for seventy-four years born and raised. I been a lot of places since I been grown, but Lord, give me Satartia! We're all as one down here. When I hurt, Miss Beverly and the others hurt. When Miss Beverly and the others hurt, I hurt too. You can't ask for nothin' no better than that. There's no better place than Satartia. That's why everywhere I go I give it the praises.

LULA BROWN GARNER *Resident*

Satartia comes from the Choctaw Indian word for pumpkin patch. No pumpkin patches anymore, just a cotton gin, a gas station, and three churches. We're just a quiet farming community nestled alongside the Yazoo River in the western part of southern Mississippi.

BEVERLY RAGLAND *Mayor*

Florida, Missouri

POPULATION: 2

I was born the thirtieth of November, 1835, in the almost invisible village of Florida, Monroe County, Missouri. The village had two streets each a couple of hundred yards long. The rest of the avenues were lanes with rail fences and cornfields on either side. Both the streets and lanes were paved with the same material. Tough black mud in wet times; deep dust in dry. It was a heavenly place for a boy. The life I led with my cousins was full of charm and so was the memory of it.

SAMUEL CLEMENS, A.K.A. MARK TWAIN
From the Autobiography of Mark Twain

I can say for sure that Florida is growing. Maybe not in population—Mother and I have been the only ones here for years—but as far as the tourist trade and Mark Twain Lake development goes, there's been a lot of progress. To the best of my knowledge, there's no local government, no mayor, no town board. Everything's taken care of around here by the state, the county, or the Mark Twain Park. We've had our trailer up for sale about three years now. We've lived here the past twenty years or so and it's time to move on. We want to live closer to the hospital. Plus, living out here puts us farther away from the kids, and we'd like to be closer to them. They live down in Mexico. Not the country, the town: Mexico, Missouri.

FLOYD ROUSE
Town Resident

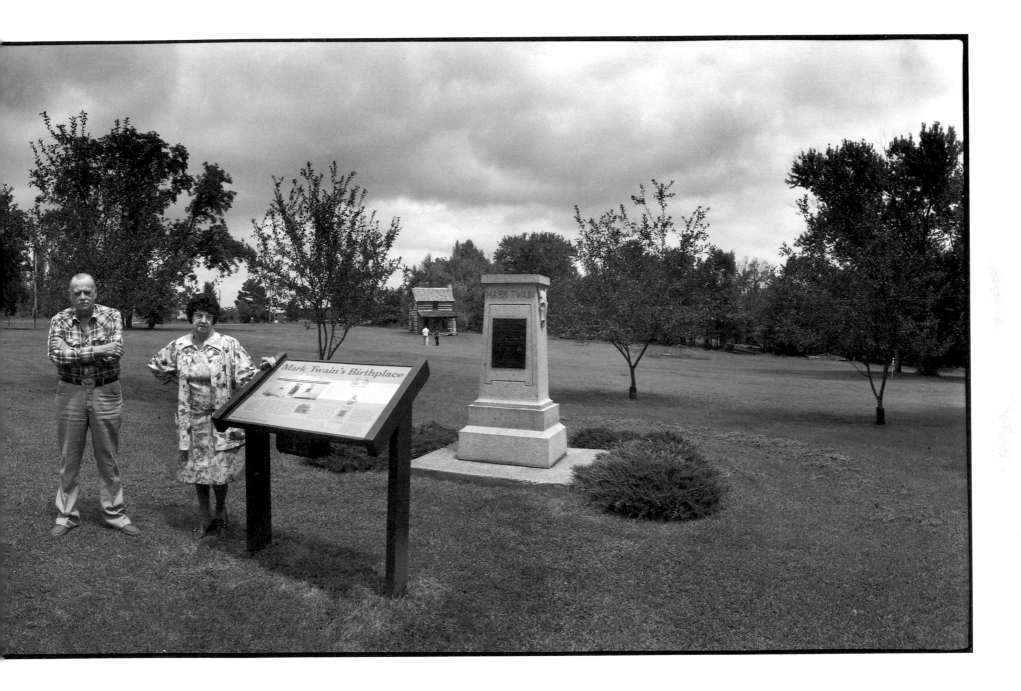

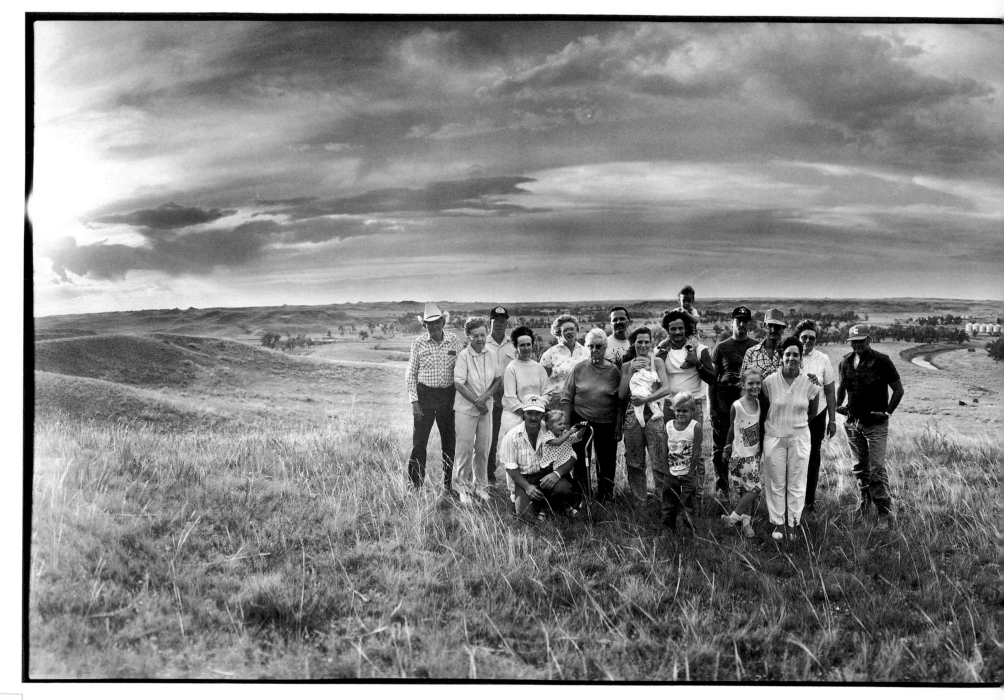

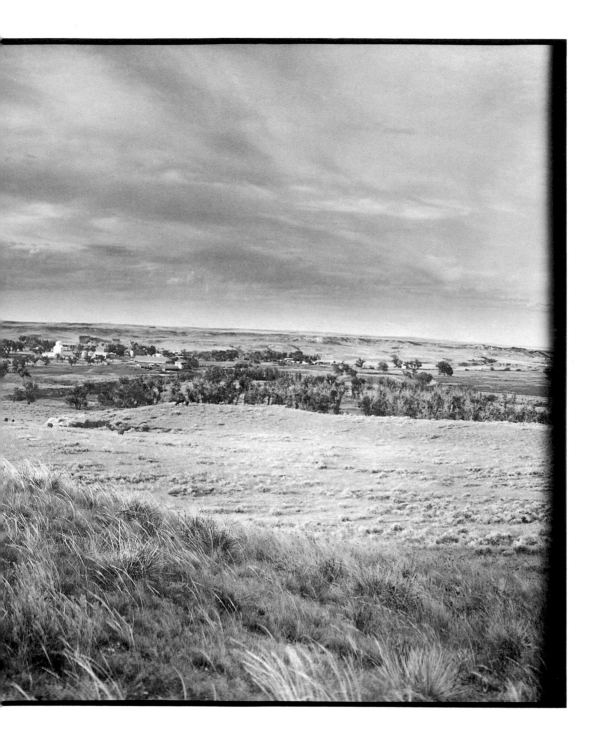

Ismay, Montana

POPULATION: *20*

Ismay was founded in 1909 by the president of the Milwaukee Railroad. Common theory is he named the town after his two daughters, Isabelle and Maybelle.

Shortly before our Diamond Jubilee in 1984, I got a letter addressed to the Ismay Chamber of Commerce, Department of Travel and Tourism. The letter said, "We are planning a trip to Ismay because my mother was born there. We would like to know the names of the biggest hotels and the finest restaurants. We want to experience all the local specialties!" I put the letter down and wondered how I should respond to someone from New York who obviously has no concept of what life is like here. Rather than write, I decided to call her. After I got her on the line, I explained that the nearest Holiday Inn was two hundred miles away in Billings, and that Ismay didn't have any restaurants. I said we did have a local cocktail lounge if she didn't mind driving eighteen miles to get to it. To make a long story short, they showed up for our Diamond Jubilee Celebration. Fact is, they had such a good time they've been back twice since then!

WAYNE RIEGER *Town Clerk*

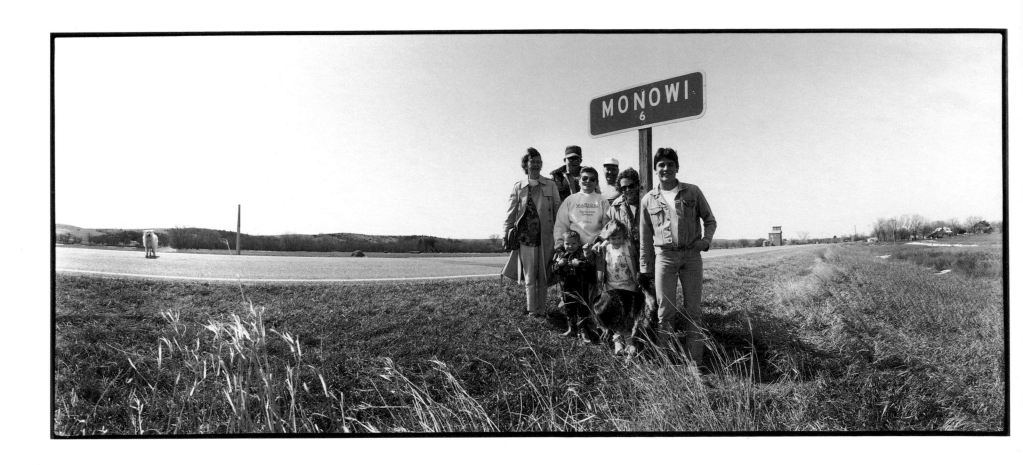

Monowi, Nebraska

POPULATION: 8

In 1902, the Chicago Northwestern Railroad chose to develop the land here and not in southern South Dakota because this was Indian territory at the time so they got the land for free. Monowi's name comes from the Indian word that means white flower.

RUDY EILER
Mayor

Monowi, Nebraska is a small incorporated village in northeast Nebraska. When census takers took the census, everybody in town filled out two sets of forms. Census workers made at least two telephone calls to each family to confirm. So now the census has been published and here's what it says: Monowi's population is six. In fact, it is eight. Nobody under age five. In fact, there are two under age five. None between forty-five and fifty-four; oh yes, there is one. No household with a married couple; yes, there are two. Elsie Eiler of Monowi says if there are this many errors in a town with a population of only eight people, why do we bother with an expensive census at all? . . . Paul Harvey . . . Good day!

PAUL HARVEY
ABC News Commentator, Noon Radio Broadcast, November 19, 1991

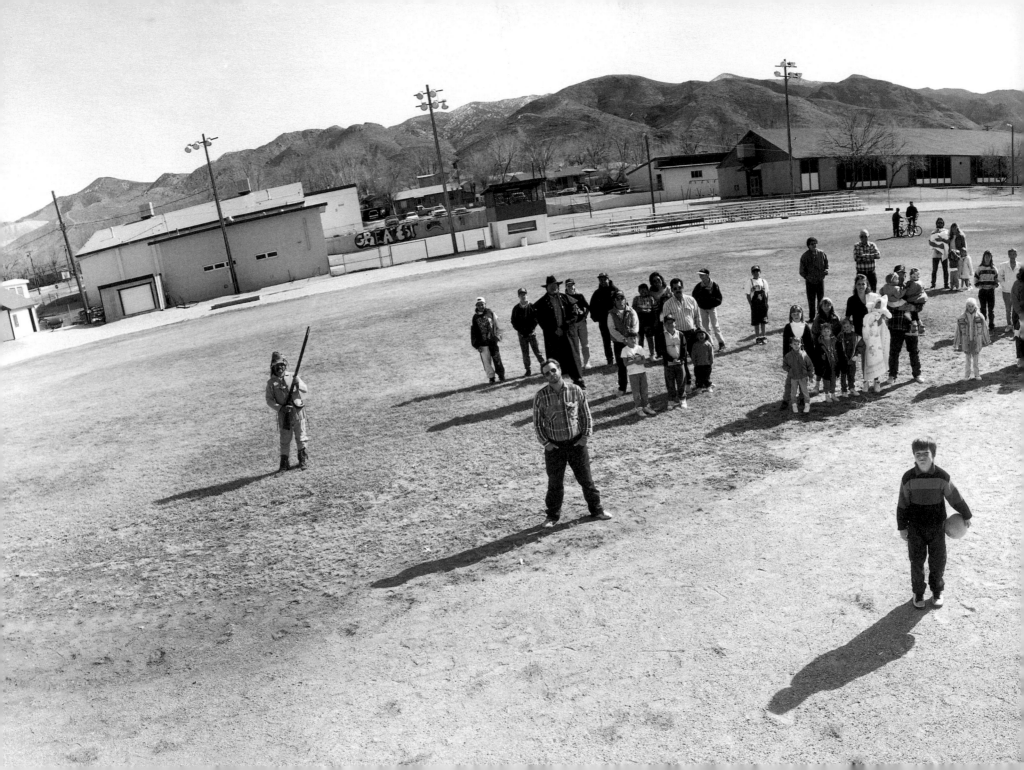

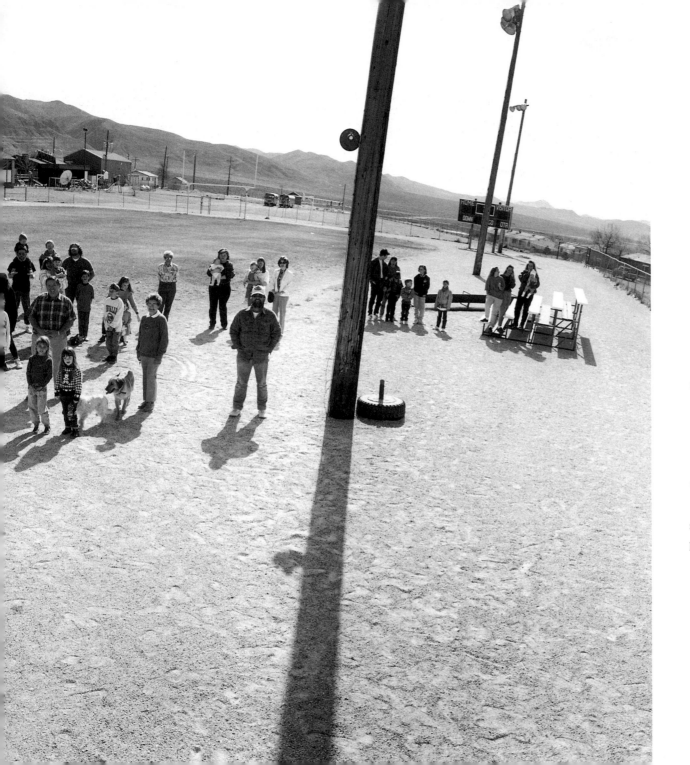

Gabbs, Nevada

POPULATION: 367

Our school mascot is the tarantula and every fall, during football season, the tarantulas migrate. Hundreds come through every year. You can open your front door and you might find one on your front steps. They don't bite, though; they're nonpoisonous.

All eleven seniors in my graduating class are going on to college. I've been invited to play football and basketball at a little school in North Dakota. I've never been to North Dakota. I can't wait to start. I've lived here in Gabbs my whole life and it's all I know. I'm looking forward to moving on. There's nothing here no more, no work or anything. Not much at all since the mine closed down. I can't say for sure, but chances are good I won't be coming back.

LEE HOUSTON
*1992–93 MVP, Gabbs High School
Football Team*

Hart's Location, New Hampshire

POPULATION: *33*

In 1772, Thomas Chadbourne was awarded a land grant from King George of England for outstanding military service in the French and Indian War. He sold the property in 1775 to Richard Hart, who renamed it Hart's Location. Today, the town is nestled in the Crawford Notch of the White Mountains in Northern New Hampshire.

MARION L. VARNEY
Town Clerk

In the summer of 1987, I ended up being the Republican Party Campaign Chairman for Hart's Location. As candidates do, they like to meet their supporters and encourage their effort. One day, our son Christopher, who was twelve at the time, was out mowing the lawn when this motorcade came roaring up the driveway to the Inn. A tall dark-haired gentleman followed two Secret Servicemen out of the limousine. They walked over to Christopher and asked if his father was at home. Christopher, whose chin was down around his knees, said "Geez, Dad's not here and Mom's out shopping and I'm here alone." The man bent down and said, "Well, hi, I'm George Bush." My son said, "Who?" "The Vice-President of the United States," Bush answered. "Oh," said Christopher. "Do you have a reservation?"

JOHN BERNARDIN
Selectman and Innkeeper

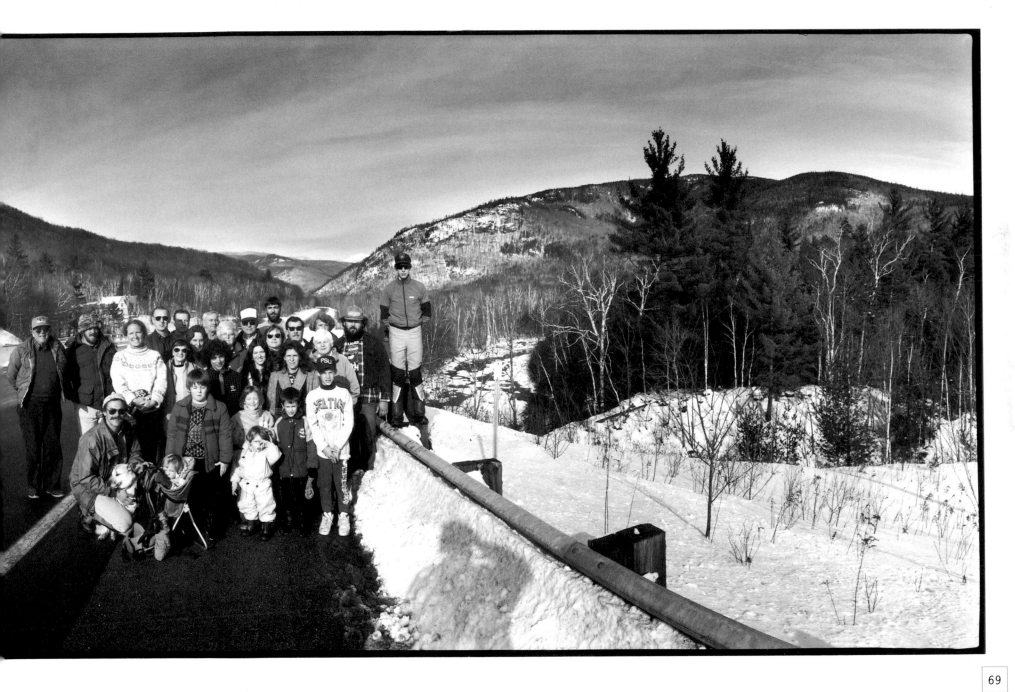

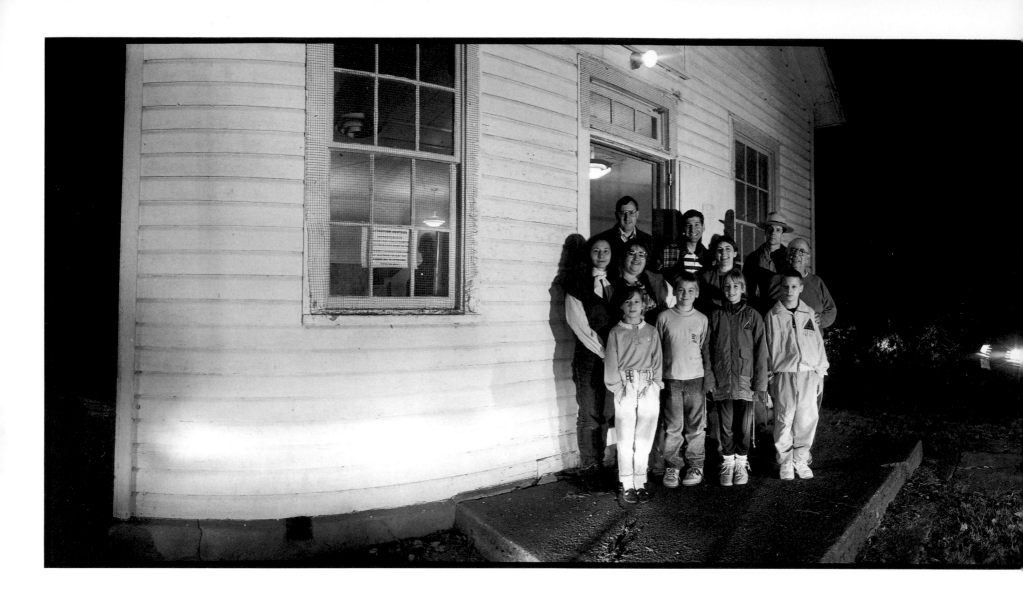

Pahaquarry, New Jersey

POPULATION: 8

It was in the mid-seventeenth century that the Old Mine Road was cut through the forests, marshes, and hillsides along the Delaware River. The township, named for the Indian settlement Pahaqualin, actually follows the configuration of this ancient road.

In 1955, the Delaware River flooded—a one-hundred-year flood. Nine people died. In 1960, in response to the flood, a dam/federal recreation area was proposed. The legislation enabling the government to begin buying up property for the project was enacted in 1963. When the reality of the government's decision became clear, many township residents became distraught. Some residents moved away, but many stayed on. Some fought the government, but all, in time, were bought out, their homes becoming federal property and they themselves going from property owner to tenant. Rules and regulations were enacted to "protect" the government's investment, to the detriment of those who remained. Businesses were no longer permitted, nor farming unless special permits were granted. Regulations were established concerning domestic animals. A policy of subtle harassment was set in place. The incorporated township still continued to operate as an autonomous municipality, as it must under New Jersey state law. Today, its relationship with the National Park Service is civil but hardly cordial. The Park Service views Pahaquarry Township and its three-member committee as an obstruction to its plans. It is. The township still continues to repair roads, provide snowplowing and de-icing in the winter, apply for grants, and provide a polling place for all elections. It operates on a small scale, but it continues to operate. When the last eight residents leave or die, Pahaquarry Township's future will not be assured.

JEAN ZIPSER *Township Committeewoman*

Grenville, New Mexico

POPULATION: *30*

Having dedicated most of my professional life over the past two decades to assisting rural communities to meet basic needs, I have a very deep conviction about a positive future for small town America. The fate of small towns throughout rural America is no longer dependent on a single major employer. The information age gives rural America access to global world markets. Many people will return home to the small towns where they grew up to enjoy the quality of life. Others will be escaping the urban setting. Our survival requires planning, entrepreneurial genius, and hard work. Without your interest, participation, and leadership it can't happen. The rural small town is an American institution that must be preserved.

LELAND D. TILLMAN
Town Resident and Executive Director, Eastern Plains Council of Government

With the men at work all day Ruth and I are left to run things all by ourselves. We drive the fire truck, operate the backhoe, and run the ambulance rescue unit. We don't get a salary. Everything is volunteer. Occasionally, I'll even take over my husband's mail route. It covers 140 miles, stops at thirty-five houses, and takes five hours to drive. The biggest problem on the route is the varmints—you know, rattlesnakes, skunks, badgers, and porcupines. I've toted a shotgun for years. When we re-did the Town Hall behind us, we killed twenty-seven rattlers in less than two months! They're a threat to our cattle and horses and to the folks here in town. Sure, they can be aggressive at times, but the real danger is that they're carriers of diseases. The town name honors Grenville M. Dodge, an early settler, soldier, politician, and promoter turned railroad man. It was named on July 19, 1888.

MIGNON SAEDORIS *Mayor*

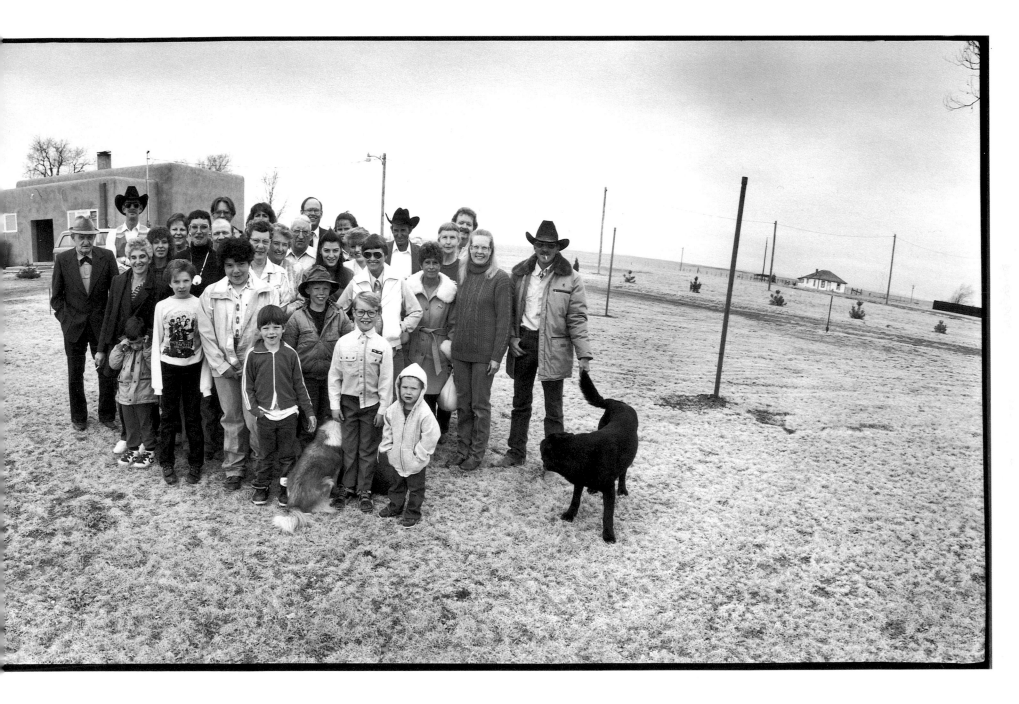

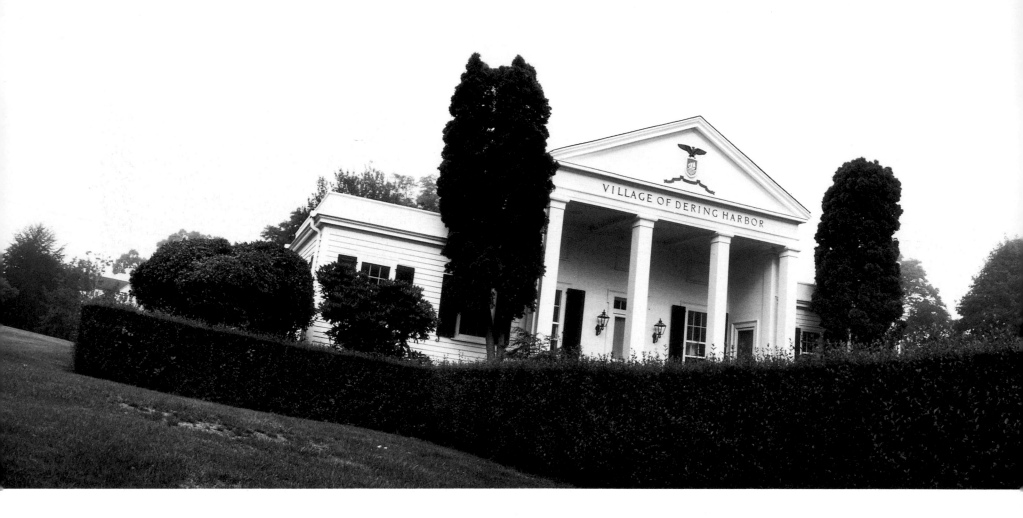

Dering Harbor, New York

POPULATION: 28

Dear Dennis Kitchen:

Our Trustees reviewed your request that this Village be included in your book on small towns. Regrettably, to do so would violate a policy of long

standing against any kind of notoriety. We are intrigued by your subject and can only hope you will be published.

Good luck. Sincerely,

THOMAS R. WILCOX *Mayor*

Dellview, North Carolina

POPULATION: *16*

My granddaddy and his two brothers needed to make themselves a town out here back in 1925. They had their chicken farm business set up out here but they were having a problem with wild dogs eating up the chickens. To make things worse, there was a law on the books that forbade you to shoot and kill stray dogs. To make a long story short, Granddaddy David P., being in the legislature, helped his brothers incorporate so they could enact the first and only law of the new charter. Namely, the right for folks to shoot stray dogs.

That old wooden sign's about the only thing left from the old chicken hatchery days. Dellview isn't a town the way most folks think of one. There's never been more than three family houses out here and probably never will be.

DR. VAN DELLINGER
Mayor

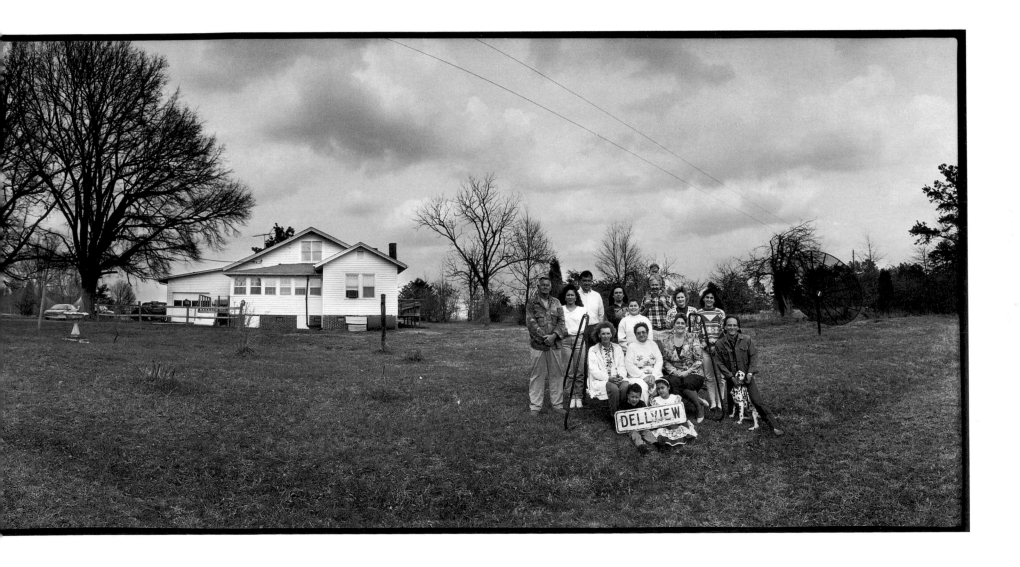

Hove Mobile Park, North Dakota

POPULATION: 2

The construction of the anti-ballistic missile site in 1970 brought new jobs and new people into the area. We opened the trailer park to give these new people a place to live. As we grew, difficulties developed between some of the residents. As owners of the facility, we were expected to settle these problems and complaints. Barking dogs, disobedient children, and careless driving were just a few of the things that needed our attention. It was my idea to incorporate the trailer park into a town as a way for these people to take an interest in solving their own problems. In 1972, we were officially declared an incorporated town by the state of North Dakota. Now, when we had a problem, we called a town meeting to solve it. Pretty soon the complaints were fewer and fewer, and you could see that the people were getting along. By 1973, we had over one hundred people living in twenty-seven trailers. That was our high point. The anti-ballistic missile site closed down suddenly in 1976, and people started moving out immediately. Hove Mobile Park was empty by 1977.

My wife Marion and I are standing here in what used to be the center of town. Gradually, we've been turning over the land, and this year we removed the last of the sewer drainage system. Eventually, the town's acreage will be converted back to field and farmland.

HOWARD HOVE
Mayor and Co-Founder

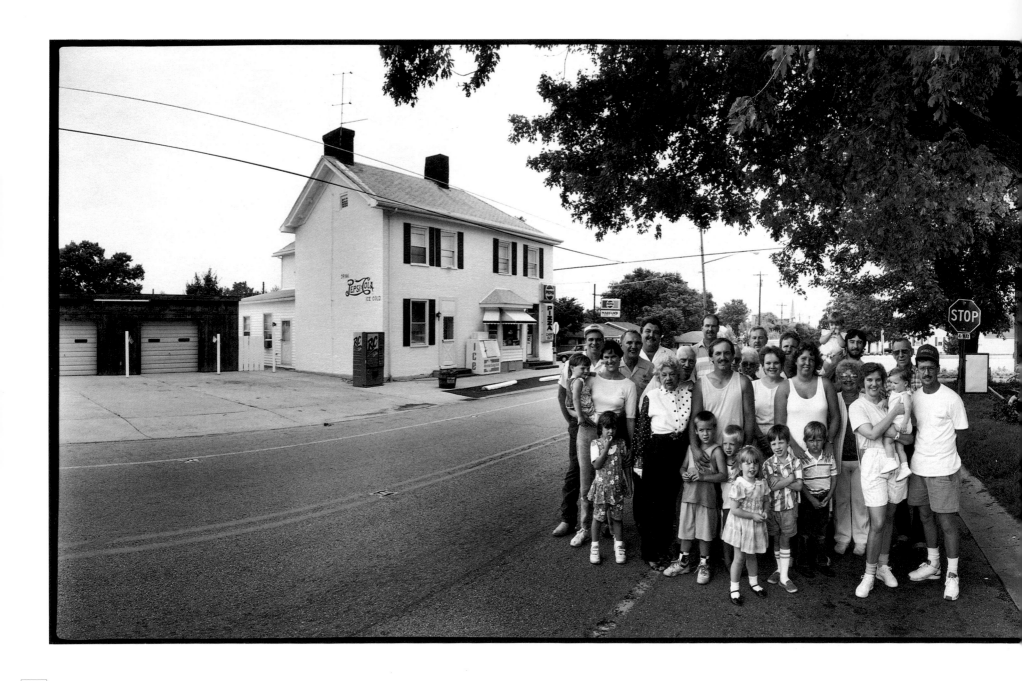

Jacksonburgh, Ohio

POPULATION: 52

My husband John prayed one day that we'd be able to get a place to live in Jacksonburgh. We both grew up in neighboring towns. In fact, John used to ride his bike up and down these hills on his way to the Carry-All Store. We moved to the city after we were married and lived in a tiny, awful apartment. We used to take a lot of drives in the country back then, and we'd always end up here. We loved the countryside and the clean streets and the nice yards. One day we saw an ad for an apartment here and we took it. Less than a year later, we were able to buy this house. We've been here ever since, and John and the kids just love it. We have thoughtful neighbors who've always been there when we needed them. We feel the Lord answered our prayer. We're happy to live in Jacksonburgh and wouldn't want to live anywhere else.

DIANE WAGNER
Town Resident

Hoot Owl, Oklahoma

POPULATION: *0*

Hoot Owl was named and incorporated by a man and his family in 1977. He put the town on the market four years ago but never got the price he wanted. Eventually, he ended up losing his town to the local bank and was evicted from the premises. That's how come the population is zero. The bank was asking $150,000, but settled for less with a fella who says he's going to use Hoot Owl's thirty-four acres as a private retreat for his family. He says he'll maintain the town's charter, too. Says his wife will be the mayor and he'll become the new sheriff and executioner.

ROSE MOORE
President, Pettycoat Junction Real Estate

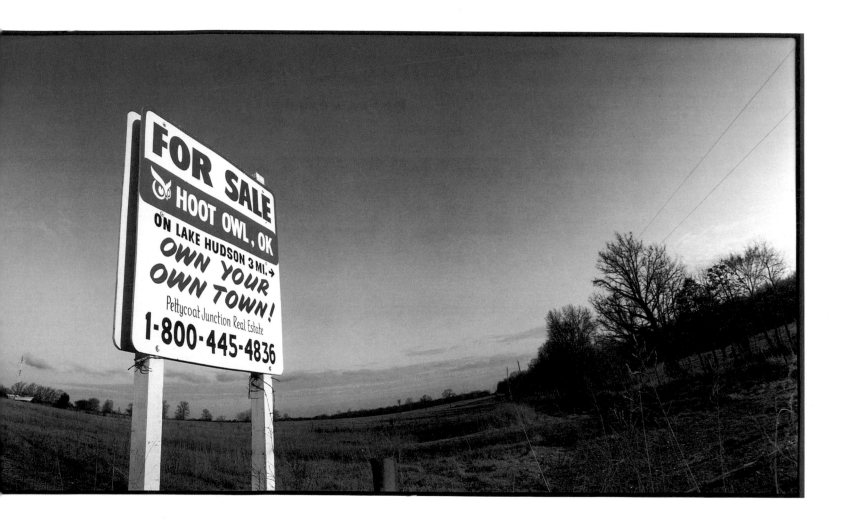

Granite, Oregon

POPULATION: *16*

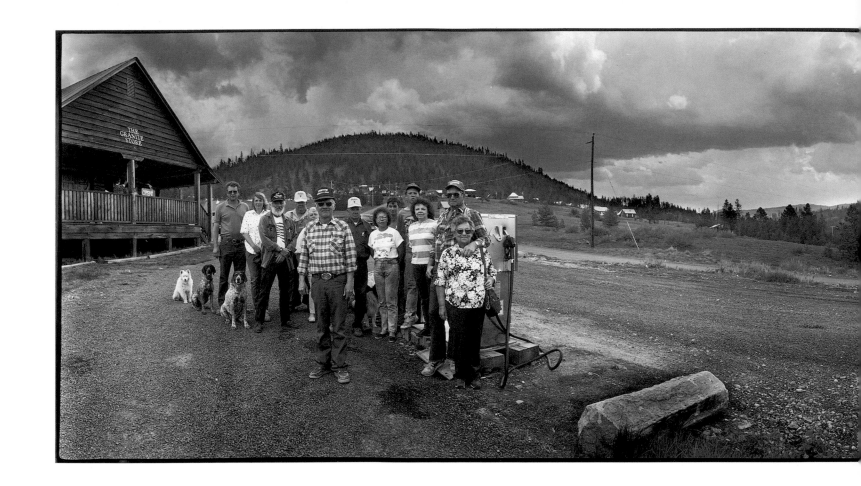

The sheriff's radio is all we have. We asked the phone company if we could just get one phone established up here for emergency calls and such. They weren't willing because they said we didn't even have enough people here to establish a 911 number. They said if there was twenty people or more we could have a pay phone here at the store. But the cost they wanted per pole and for hanging the wire was too much, so we decided to go without. It's just as well; we love the peace and quiet. We hunt and fish and drive around and look at the wildlife. Just have piece of mind, mainly.

MARGARET IHRIG *Resident*

Albert Tabor struck gold here in the Blue Mountains on July 4, 1862. He named his claim the Independence. The town that sprang up around it was also called Independence. The name was changed to Granite in 1876 because of all the granite around here, but mostly because they discovered that there already was an Independence, Oregon.

JACK NOREEN *Mayor*

S.N.P.J. (Slovenska Narodna Podporna Jednota), Pennsylvania

POPULATION: *20*

Leaving North Beaver Township to form our own borough was the farthest thing from anyone's mind back then. Our Slovene National Benefit Society (S.N.P.J.) is a fraternal organization that was formed in 1904 to provide Slovenian immigrants to this country with insurance. When the organization bought this farmland in 1966, it was to be the site of our national recreation center. The trouble started when North Beaver Township officials told us that it was against the law to serve alcoholic beverages anywhere within the city limits. We didn't have much of a choice, so we petitioned, filed, incorporated, and officially formed the town of S.N.P.J., Pennsylvania, in 1977. Now, with our own liquor license, we're free to serve mixed drinks and beer to our members at our weekly picnics, polka dances, and bingo games.

JOSEPH P. CVETAS
Mayor

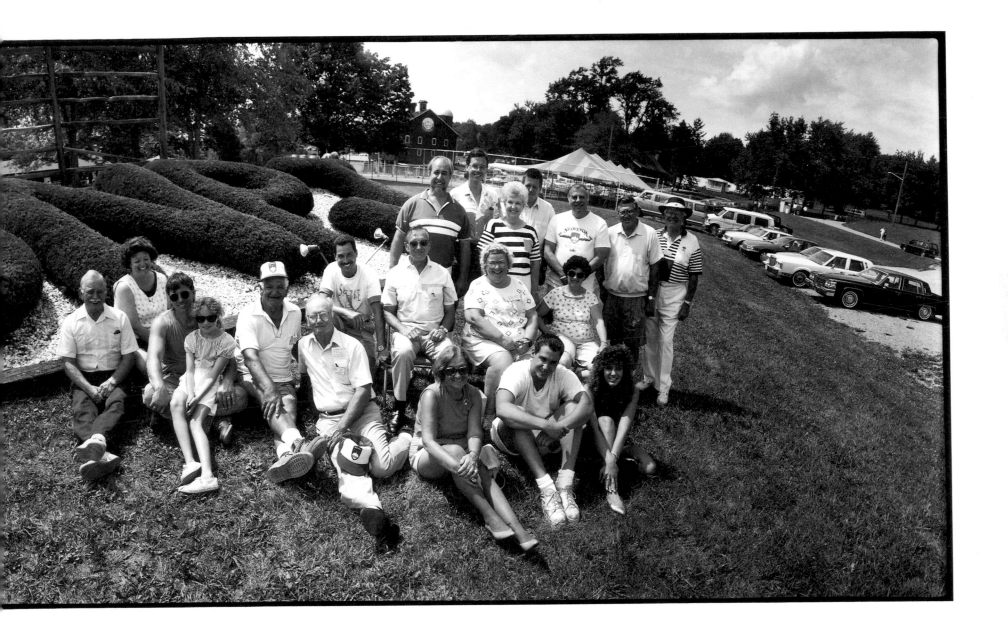

Block Island, Rhode Island

POPULATION: *820*

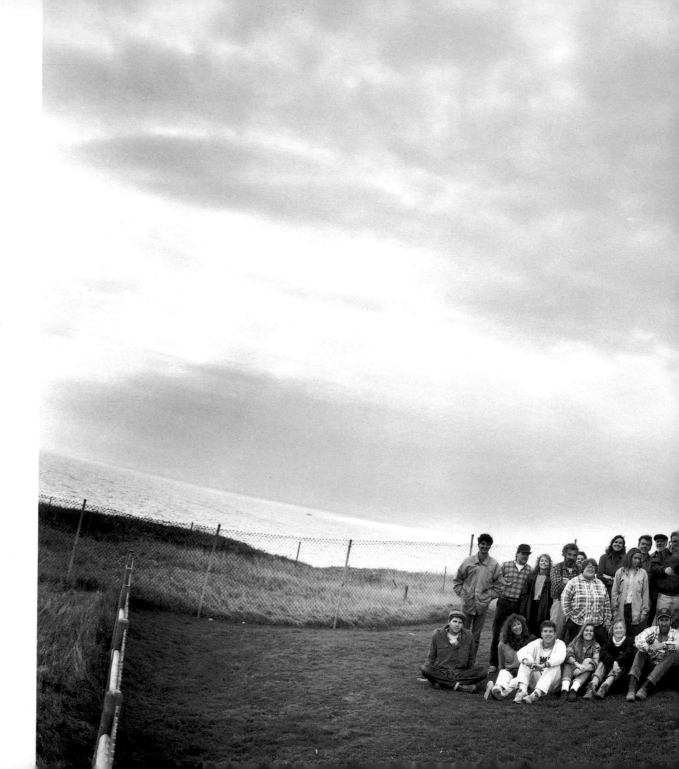

In 1524, on his way to what he thought was Asia, the Italian explorer Verrazanno discovered our small three-by-seven-mile island. In 1614, a Dutch navigator named Adrian Block charted the island's location, and it has since come to be known as Block Island.

Everything on this island revolves around tourism. This place is a boomtown in the summer. For example, our year-round population is 820, but on any given day in August there can be as many as fifteen thousand people on the island. The Mohegan Bluffs shoreline that the Southeast Lighthouse is built on is eroding at a rate of three feet per year. Fifteen months ago, a large grassroots effort began to raise money to transport the hundred-year-old beacon back two hundred feet to safer ground. We recently learned that our work has been rewarded with matching state, federal, and private grants. This effort was largely a community undertaking, and the residents of Block Island have a lot to be proud of.

PAMELA BUOL
Executive Director, Block Island
Chamber of Commerce

88

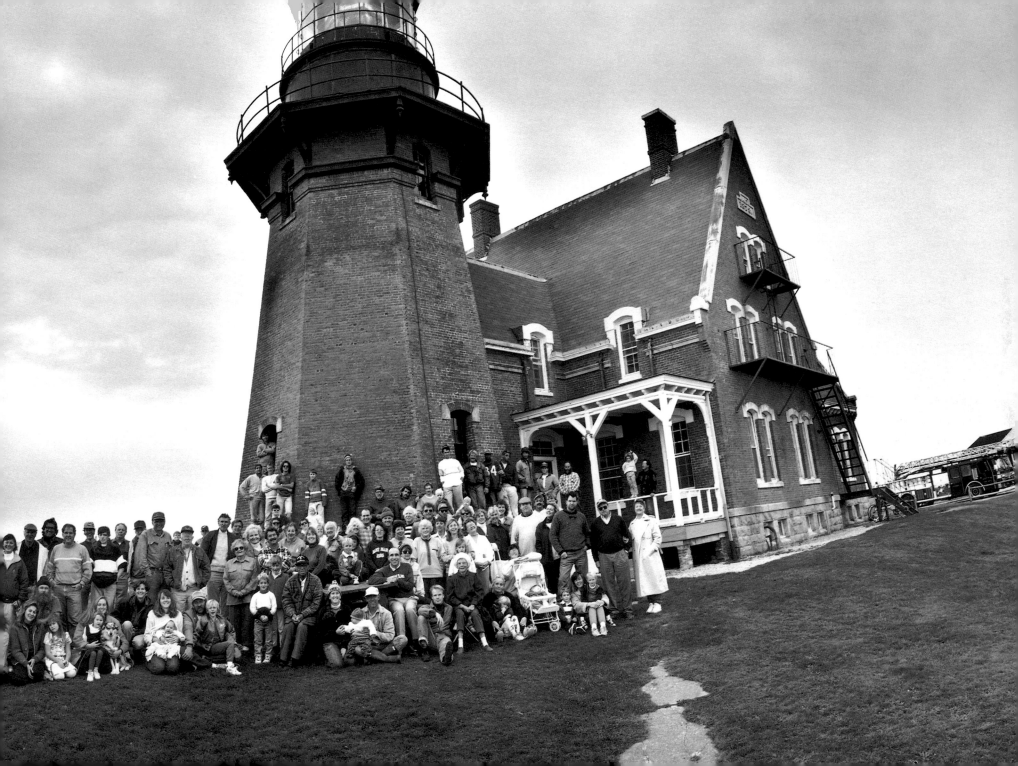

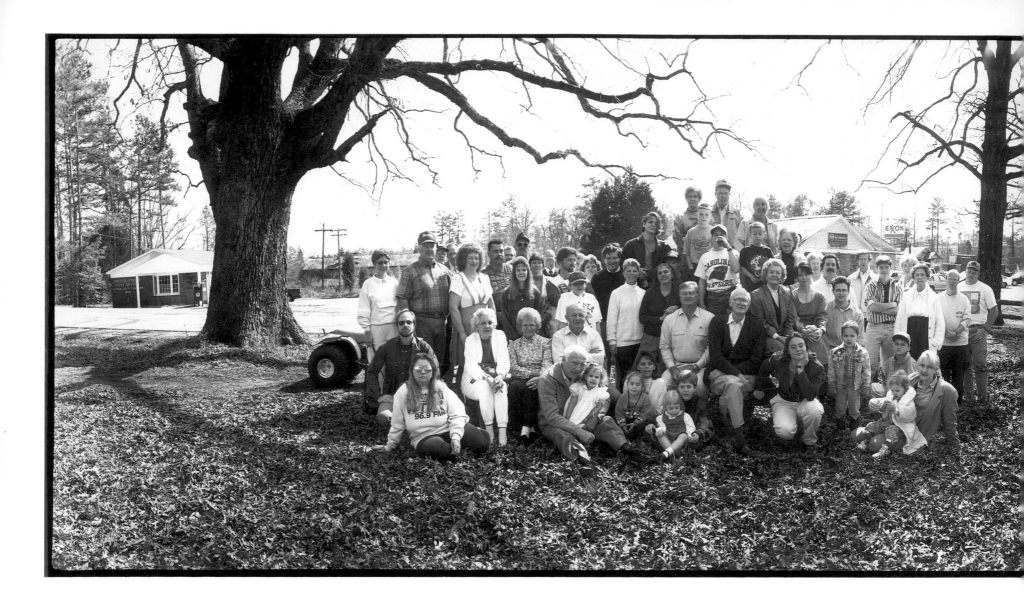

Smyrna, South Carolina

POPULATION: 57

We were new in town when my wife came home one day before Easter and said, "You've got to deal with Cain; she's blue—as in aqua!" Our dog, Cain, showed up blue one day, like a ghostly apparition on the lawn. Few things in a tiny town remain a mystery very long, and we soon discovered Cain had fallen into the printing mill's outdoor dye pond. Naturally, when folks saw the colored dog they'd say, "Minister, around here, we just dye the eggs."

ANDY PUTNAM *Minister, Smyrna ARP Church*

The town of Smyrna was named for the Smyrna Associate Reformed Presbyterian Church. At the time of its incorporation in 1895, all the families in town were members of the church.

FRANCES FAULKNER *Town Clerk*

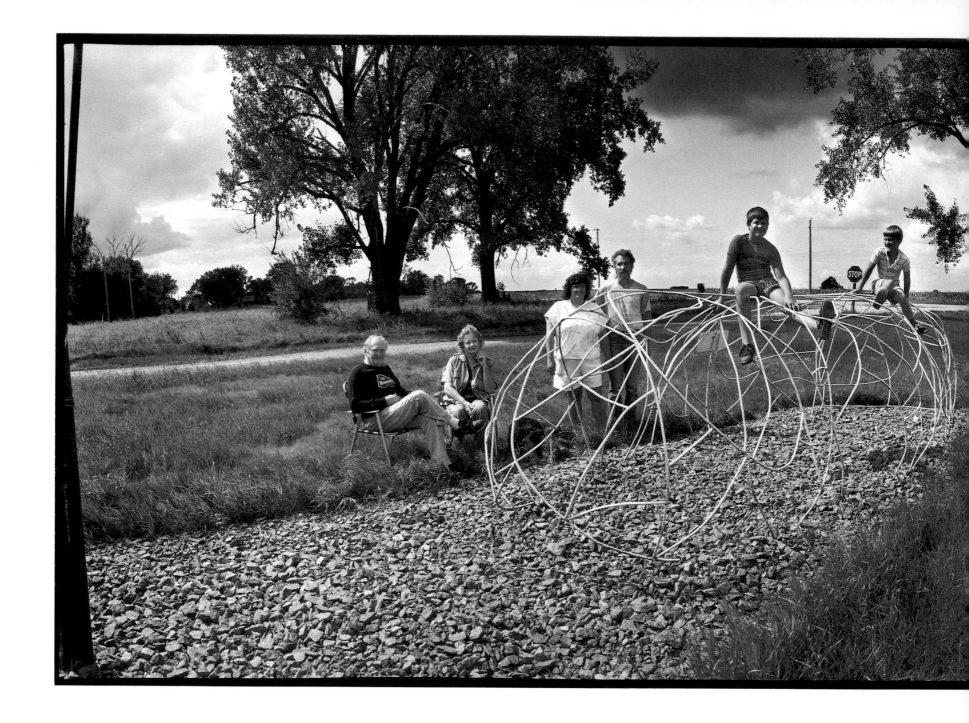

White Rock, South Dakota

POPULATION: 6

White Rock was founded in
1884 by Richard F. Tyler, a real estate man from Fargo
[North Dakota]. He named the town after the rock that used
to be here. The original white rock was dynamited in 1899
to make room for S. E. Oscarson's new grain elevators.

In 1984, to raise money for the
centennial celebration, we went over to the site and dug up some
pieces of the original white rock. We crushed up what we
found and poured the pebbles into plastic key chain holders.
We sold them for a dollar each. The money we made from the
key chains was used to pay for this new White Rock replica. It
was designed and built by my son Randy. He welded iron rods
together and painted them white.

JERRY ANDERSON
Mayor

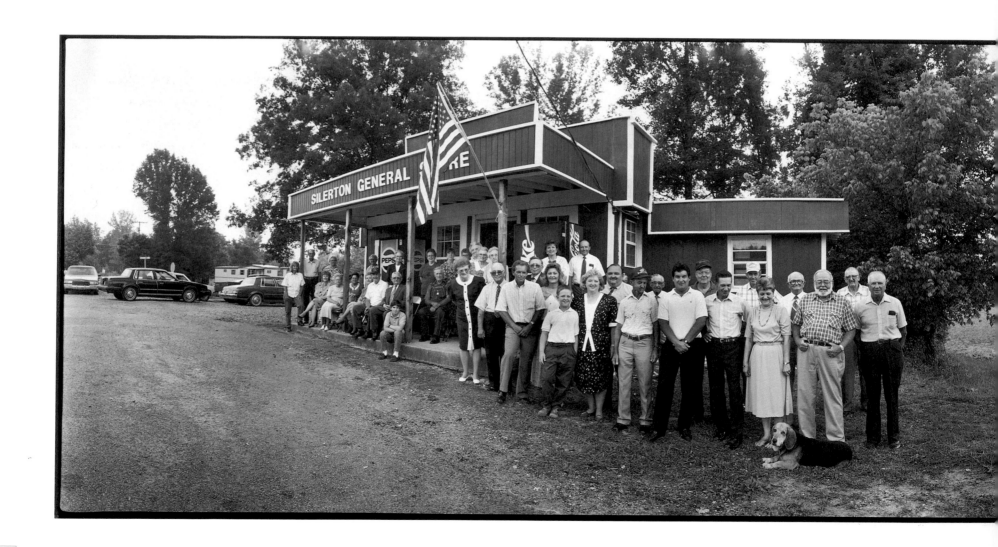

Silerton, Tennessee

POPULATION: 47

The town was originally named Silers, but the new B.M.N.O. Railroad kept mixing up our mail with a little town over yonder named Serles. We avoided any future mail mixups by changing our name to Silerton in 1918.

Speaking of mail, I reckon we have somewhat of a unique post office situation here. It's located in my kitchen. Everyone in town is assigned their own pigeonhole, and all thirty-eight boxes are lined up in my kitchen. The hours are supposed to be from eight in the morning till noon, but being it's in my house, I stay home most of the time. If I'm in another room when they come—I know all their voices anyway—I just holler, "Help yourself!," and that's what they do.

BIVIAN SILER NAYLOR
Postmistress

Mustang, Texas

POPULATION: 27

In 1969 a fella by the name of Bill MacAlheney bought up a hundred acres of land next to Highway 45. It was all mesquite pasture back then, a place to run wild horses. That's how the town got its name. Mr. MacAlheney wanted to incorporate this area into a town so he could build a 450-seat country-western dance club. The state said to incorporate you need at least two hundred people living there, so he created the trailer park to draw in enough folks. Once the town was established he opened his club.

GLENN ALBRITTON
Mayor

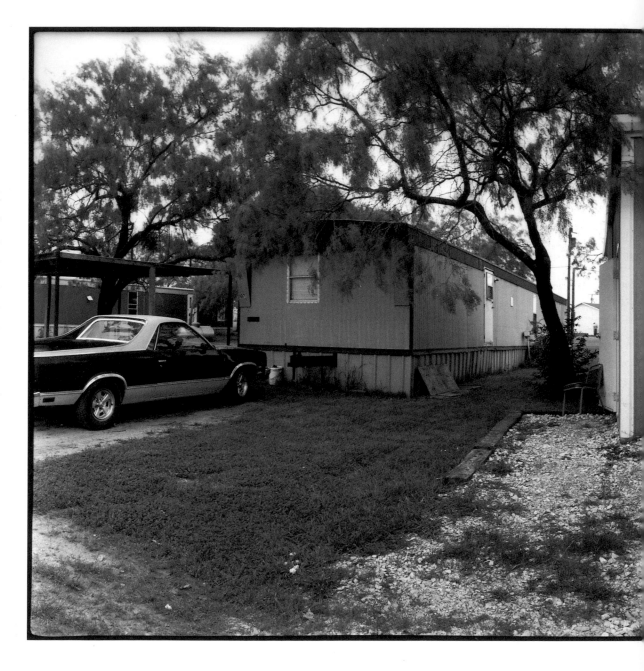

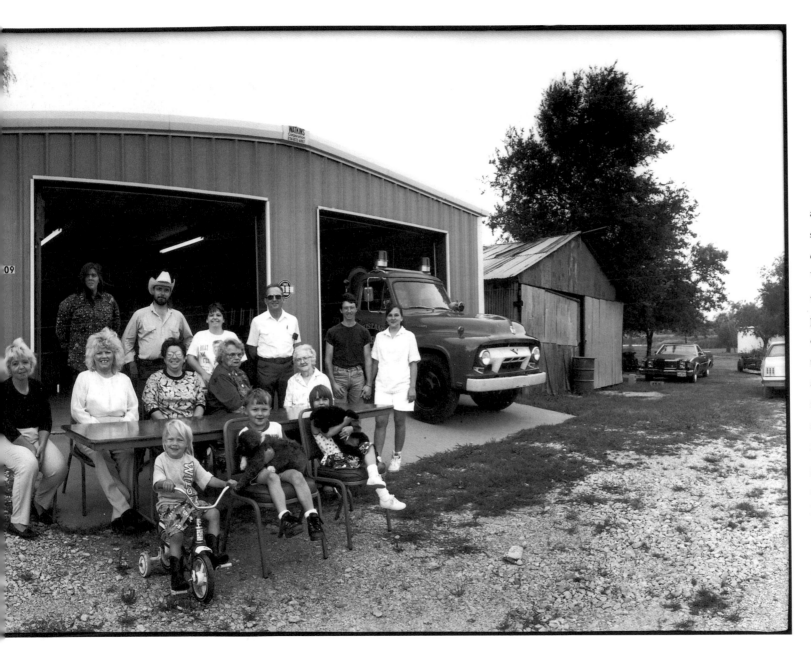

It's an exceptionally quiet town, of course, but it's subject to trouble because it's located on the interstate highway. When both clubs are packed on the weekends we have lots of folks passin' through and duckin' in and out of here. Besides the clubs and trailer park, we have a liquor store, a firehouse, and a well-stocked fishin' pond. Wally, a seven-foot alligator, has been livin' out back for almost a dozen years. Our local game warden says to leave him alone, says it's a natural habitat for him. Says as long as he's fed, he won't eat nobody.

JIM MESKER
City Marshal

Ophir, Utah

P O P U L A T I O N : *22*

Colonel Connor's soldiers came here in the 1860s in search of lead for the war effort.
What they found was an abundance of silver deposits. By the time of town's incorporation in 1906, the production of silver from this canyon
exceeded $15 million. Ophir, which rhymes with *gopher*, was named for the fabled mines of King Solomon.

Over the years we've seen to it that Ophir always had a fire truck, but since we never had
a station the trucks always deteriorated. After getting our last truck, I made sure we'd protect it this time. We built the new Firehouse/
City Hall building ourselves with donations from local businesses, organizations, and townspeople. We're mighty proud of it. The old hose-
lay machine over there is what they used in the olden days. The water was channeled down the canyon in wooden pipes that had outlets.
The firemen would hook up to them and take the water hose from the pipe to the fire.

WALT SHUBERT
Mayor

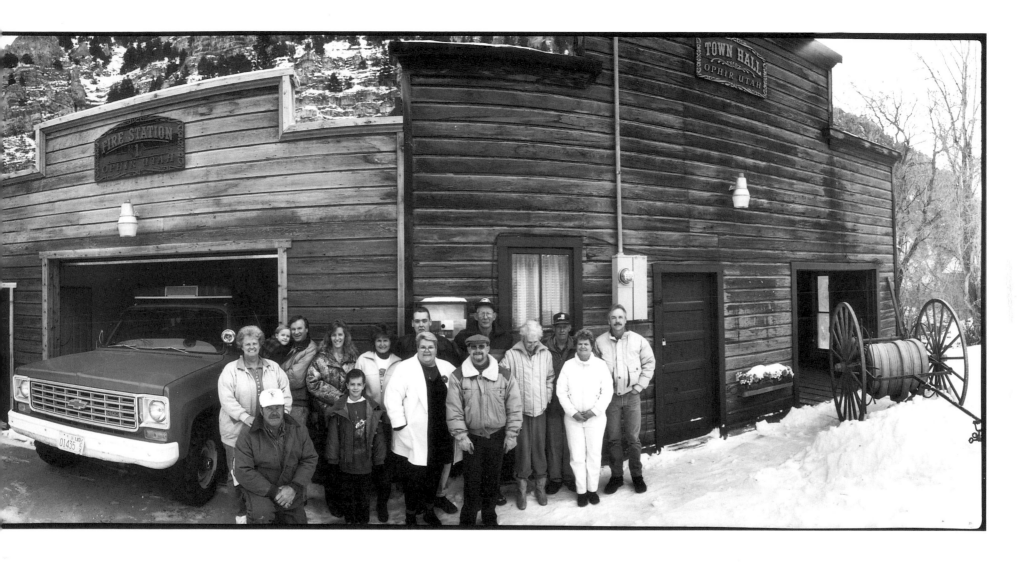

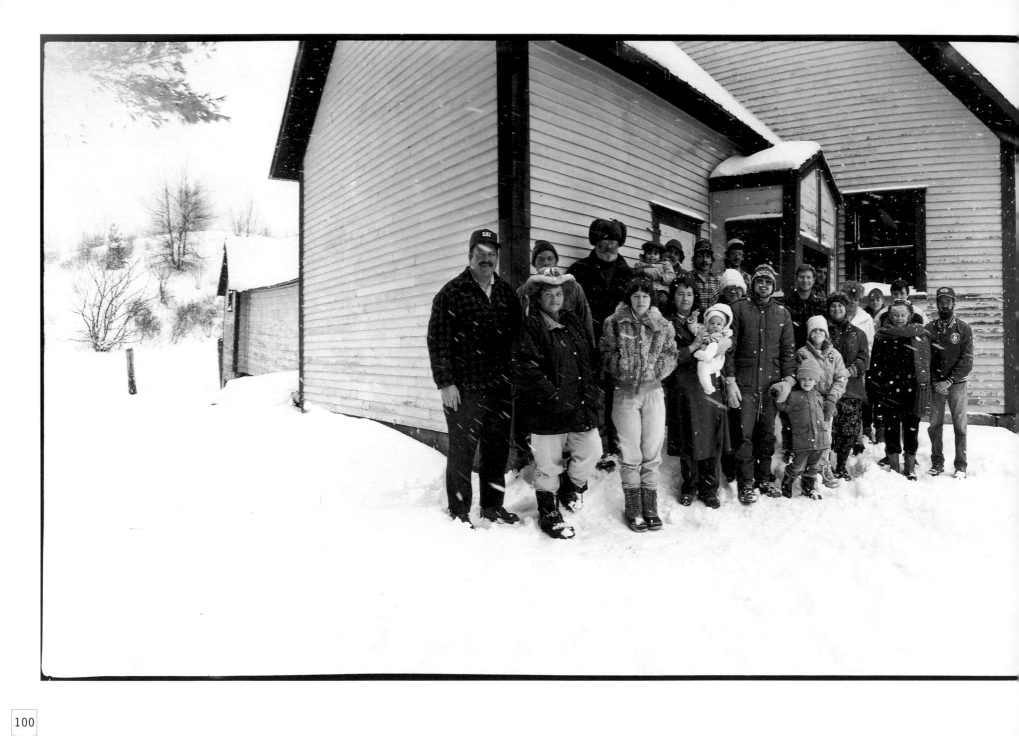

Victory, Vermont

POPULATION: *28*

The Old Schoolhouse here is only used once a year for our town meeting. We've got two school-aged kids here in town, but they go to school up in St. Johnbury. We have a school budget, but it's limited. In fact, it's so tight that if a young family moved into town with kids who needed schooling, we'd have to raise everybody's taxes. That's why we try to discourage anyone from moving here. We don't discriminate, but we do try to keep it down to a minimum.

WALTER MITCHELL *Selectman*

Duffield, Virginia

POPULATION: 52

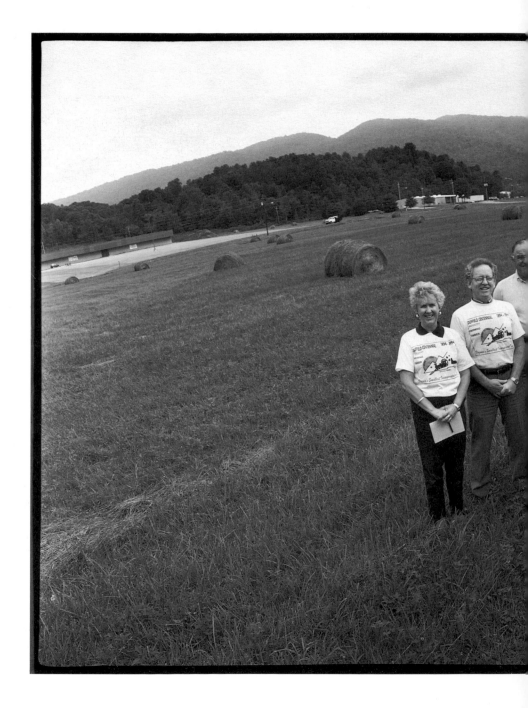

Aside from having a Ramada Inn in the middle of a cornfield, I suppose the most unusual thing about our town is that we haven't had to hold a mayoral election here in over a hundred years. The original town charter, which dates back to our incorporation in 1884, states that the four-member town council has the power to fill any vacancies which occur and may also remove any council member if a majority supports the action. If we were forced to face elections every two years, we would probably not be able to fill the ticket, because many good people just won't run for office. In a little town our size it's also hard to challenge qualifications or deal with last-minute write-ins for candidates who really may not be qualified. The way the charter was set up, the councilmen can select people to fill up two vacancies, and those who are willing to serve do so in harmony and work well together.

Jim Whiten, the manager over there at the Ramada, has been inviting the entire town to breakfast on its birthday during the Duffield Daze for the past three years. I had a hunch we'd get a good turnout for your picture if we scheduled it around breakfast time. Looks like the whole town showed up; I think you got nearly everyone.

CARL PETERSON
Mayor

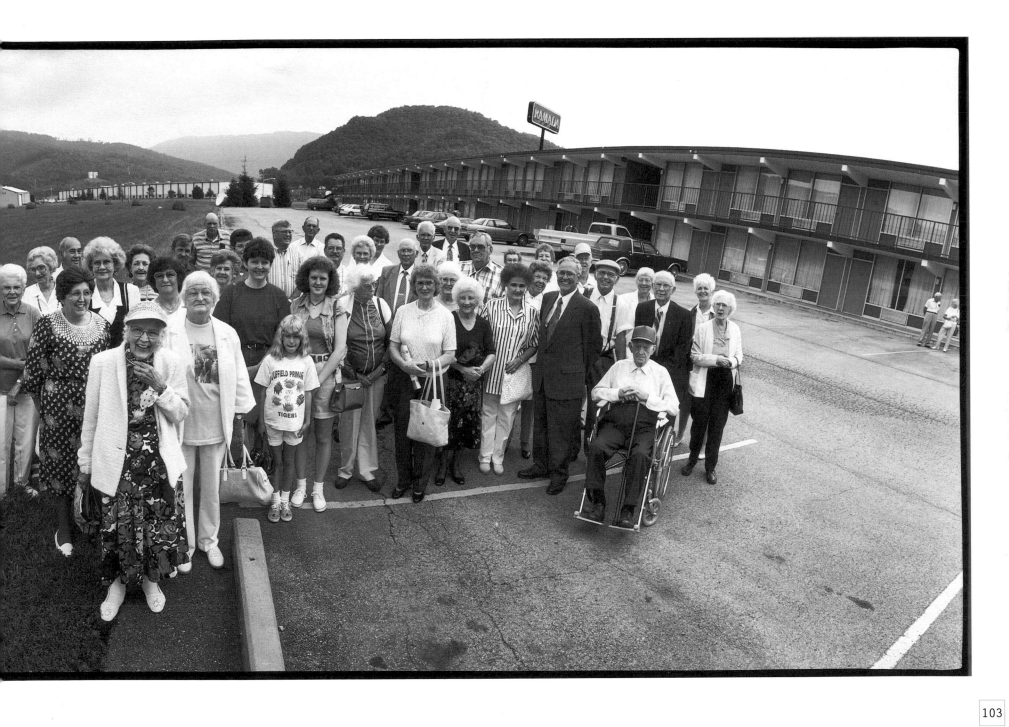

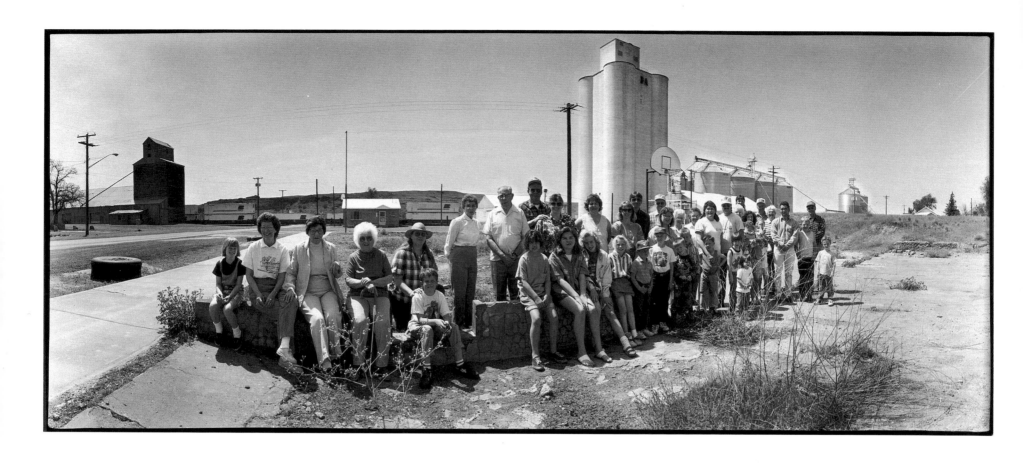

The incident involving the town's two names happened when I was a little girl. From what I've been told, there was a Krupp munitions facility in Germany during World War I and the people of Krupp didn't like the name association. They wanted to rename the town after its founder, Henry Marlin. The problem was, they didn't have enough citizens to reincorporate under a new name. That didn't seem to stop them, though; its been called Marlin ever since, even though it's officially the town of Krupp. What they didn't realize back then was that there was a munitions facility in Germany named Marlin, too.

Marlin, town of Krupp, Washington

POPULATION: *54*

I write a weekly column called "The Marlin Message." It appears in the neighboring town's newspaper, the *Odessa Record*. I took over for Reverend Grable's wife, Leona, when she retired in 1966. I write about who came to dinner and what they had to eat and such. I cover birthdays, funerals, holidays, and visitors to town, like you. I get the article to them on Tuesday and the paper comes out Thursday. It costs me more to send it than what they pay me to write it. They give me a free subscription, though. You'd be surprised how interested people are in this place, even though nothing very exciting ever happens here.

GRACE KALLENBERGER *Resident*

Brandonville, West Virginia

POPULATION: 47

Just had another birthday—my ninety-first! Been here since 1932 and can say without hesitation there's no better place to rear your family. We aren't exposed to drugs and all those things that a lot of other people are, and we're not afraid to let our kids go out alone. It's always been a kind, quiet place filled with nice, helpful neighbors. The town picnic gives us a chance to all get together once a year. The ladies bring covered dishes of food, and the men cook the chicken in the ground. We had zucchini casserole, baked potatoes, coleslaw, watermelon, rolls, lemonade, and my special twenty-four-hour salad.

The town was named for Jonathon Brandon, a businessman who founded the Brandonville Stove Company. It's closed down now, but at one time the town was famous for being known as the home of the Brandonville Stove.

NELLIE HARNED
Oldest Town Resident

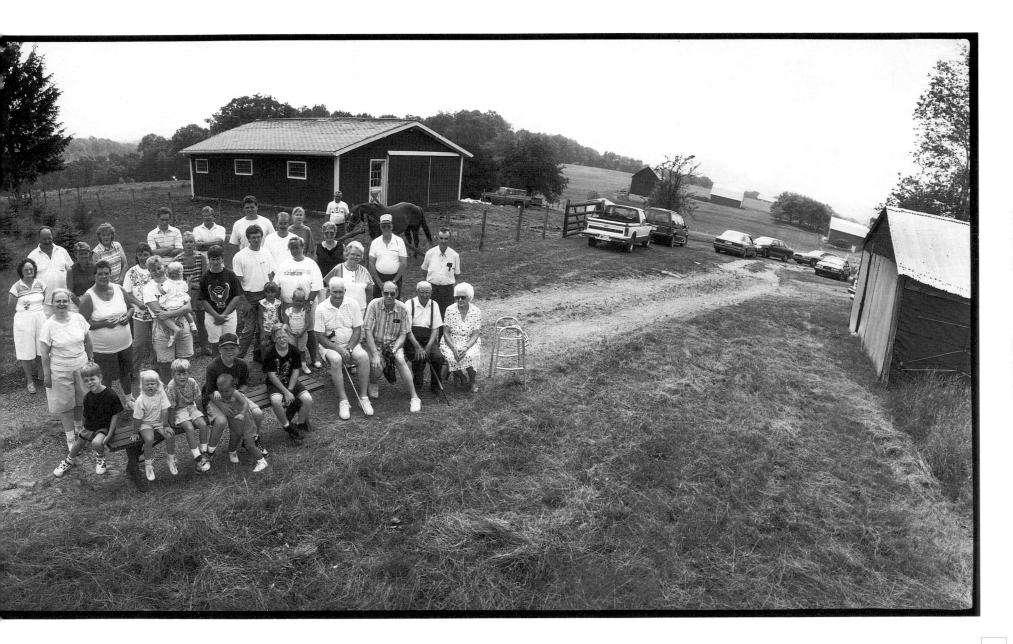

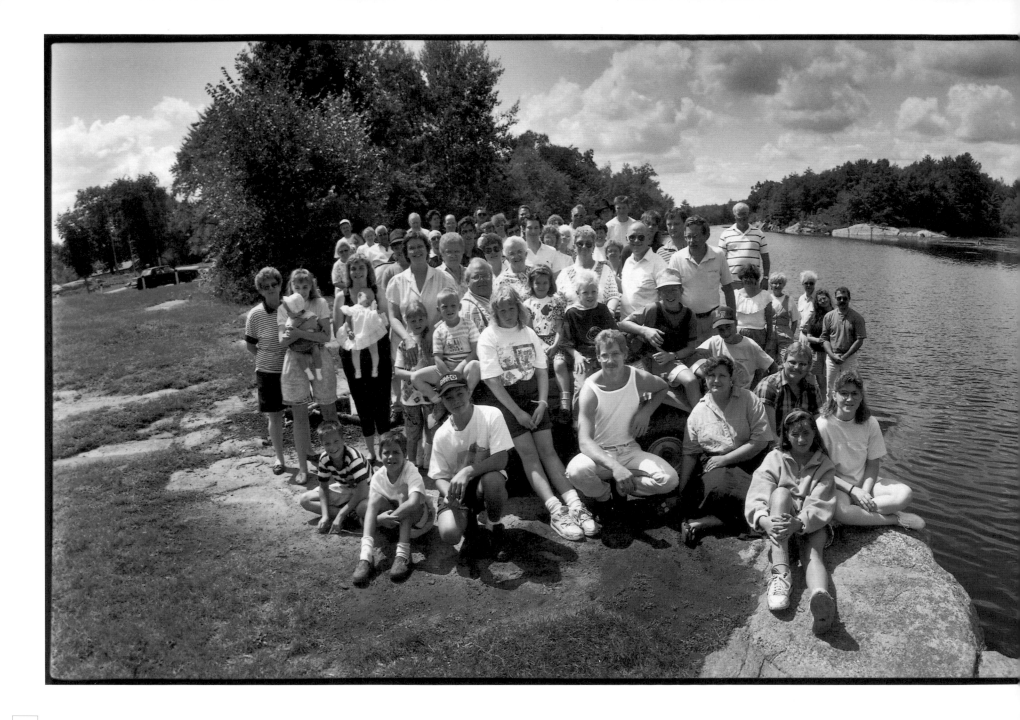

Big Falls, Wisconsin
POPULATION: 75

Our big project this year was getting the town's thirteen street signs put up. I didn't even know the streets had names until I discovered them on an old 1937 land plat. This is gonna make the folks at UPS real happy. For years we've been making up phony addresses for them because they require an exact street address for all pickups. It's really just a formality, because the driver knows us all by name anyway. Numbering all the houses is our project for next year. It will give our out-of-town emergency-services people an easier time of locating us.

KATE BRAMMEIER
Village President

Big Falls may have possibly become another Detroit at one time, as Henry Ford was looking for a site for his automobile manufacturing plant. We understand he made a very good offer to the village for the water rights to produce the needed electricity, but the village officials turned him down in favor of the Wisconsin Power and Light Company. At the time, the village thought it would be a safer and more fruitful venture. What a mistake we made! After many years of stagnation and the feeling of keeping things as they had been, meaning no growth and discouraging "outsiders" from living here, it appears a new attitude is finally developing here. We're trying to adopt a willingness to accept new ideas for change. Time will tell, as we still do have the one great disadvantage, which may eventually also disappear with new technology. That is not having any sewer and water service capability, due to the bedrock foundation we sit on.

Big Falls was incorporated in 1921 by the village board members. It was originally a logging town and was named for the thirty-foot drop on the Little Wolf River.

ARNOLD HEDTKE
Village Resident

Lost Springs, Wyoming

P O P U L A T I O N : 3

We have the distinction of being the smallest incorporated town in the United States with a post office. The town's name comes from the natural spring waters up here that disappear in the summers and return in the spring and late fall. Near as I've heard, in the spring of 1860, a wagon train master by the name of Howard spotted our springs as he passed through here on his way out west. When he came back through here in the early fall, the springs were gone. In its place he drove a stake in the ground and hung a small handwritten sign from it. The sign read Lost Springs, and that's how we got our name. We first came out here to look at the place in 1969. The wife said it best back then, when she said she always wanted to get up some place where she could spit without spitting on her neighbor.

BOB STRINGHAM *Postmaster*

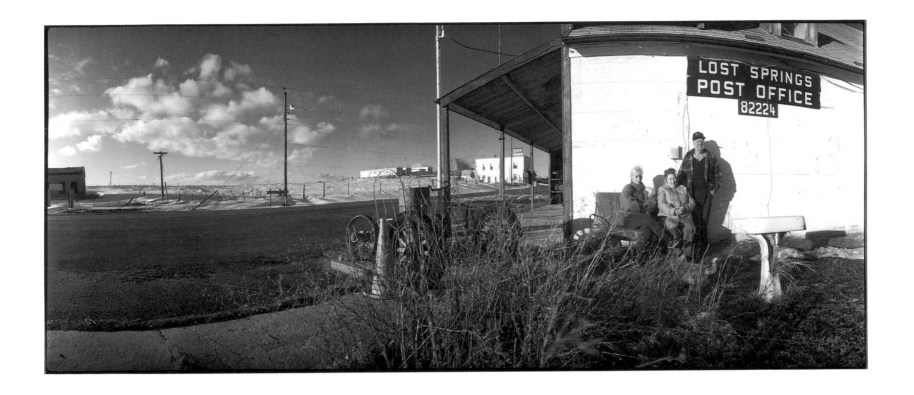

The Lost Bar's open almost twenty-four hours a day during hunting season, and all the trailers I own out back are rented full up with hunters. There's free camping across the street in the park and electrical rental outlets for all the RV's. There can be as many as two hundred people here on any given night during hunting season.

People said I was nuts, but the best thing I ever did was put a shower in the old furnace room. If you been hunting all day, who wants to drive thirty miles to take a shower when for three dollars they can take one right here?

LEDA PRICE *Mayor*

An oversized limited edition of original hand-toned sepia
silver prints produced by the photographer is available.
For information, write to:

Dennis Kitchen Studio
115 1/2 Crosby Street, New York, NY 10012